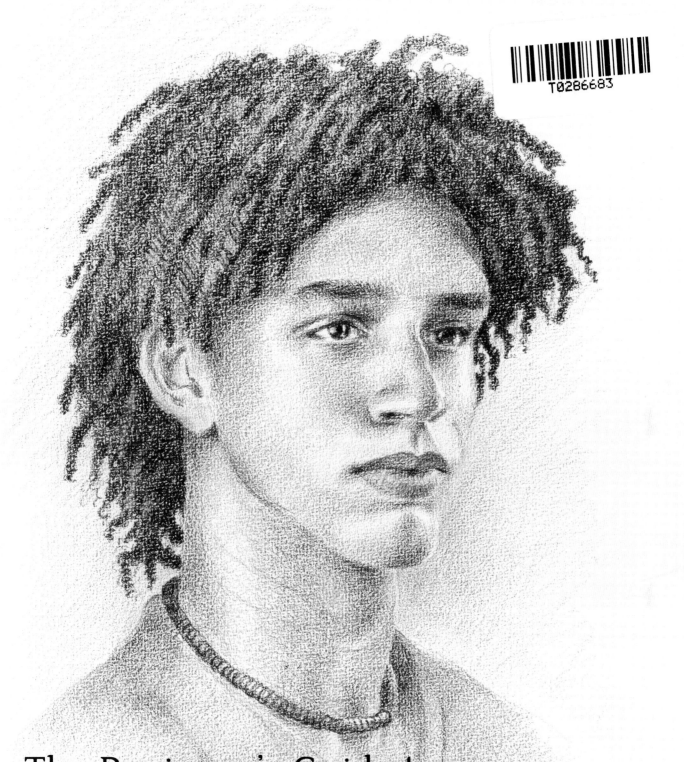

The Beginner's Guide to
DRAWING
PORTRAITS

Dedication

For my granddaughters; and for Eric, Charity, Sam, Al and Annie.

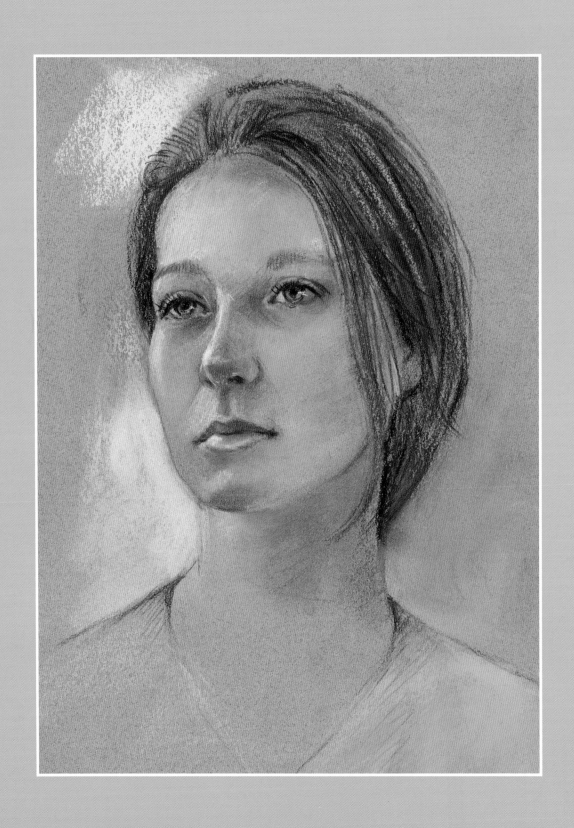

Carole Massey

The Beginner's Guide to
DRAWING
PORTRAITS

SEARCH PRESS

This edition published in 2021

Search Press Limited
Wellwood, North Farm Road,
Tunbridge Wells, Kent TN2 3DR

Reprinted 2021

Contains material originally published in
2012 as: *Drawing Masterclass: Portraits*

Illustrations and text copyright ©
Carole Massey 2012, 2021

Photographs and design copyright ©
Search Press Ltd. 2021

ISBN: 978-1-78221-795-4
ebook ISBN: 978-1-78126-752-3

The Publishers and author can accept
no responsibility for any consequences
arising from the information, advice or
instructions given in this publication.

Suppliers
If you have difficulty in obtaining any of
the materials and equipment mentioned in
this book, then please visit the Search Press
website for details of suppliers:
www.searchpress.com

You are invited to visit the author's website:
www.carolemassey.com

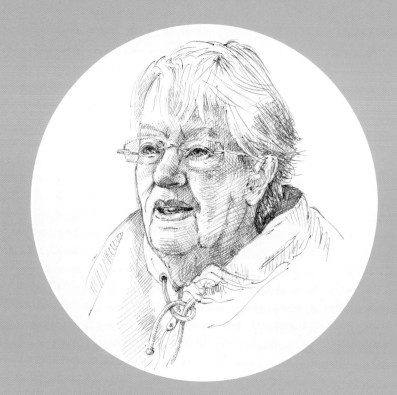

Acknowledgements

My sincere thanks to Edd, my editor, Katie and all the team at
Search Press. Huge thanks to Eric and to Charity for their support
and for checking it all made sense – both visually and literally. I am
also indebted to all those inspiring models who are represented
in this book, some of whom sat for me, or allowed me to sketch or
snap them; others were just faces in photographs but whom I felt
I knew nonetheless.

Front cover
MOTHER AND BABY *Pastel pencil*

Page 1
PIERS *Coloured pencil*

Page 2
IONA *Soft pastel*

Page 3
SOLOMON *Charcoal*

Above
BERYL *Pen*

Opposite
LI *Coloured pencil*

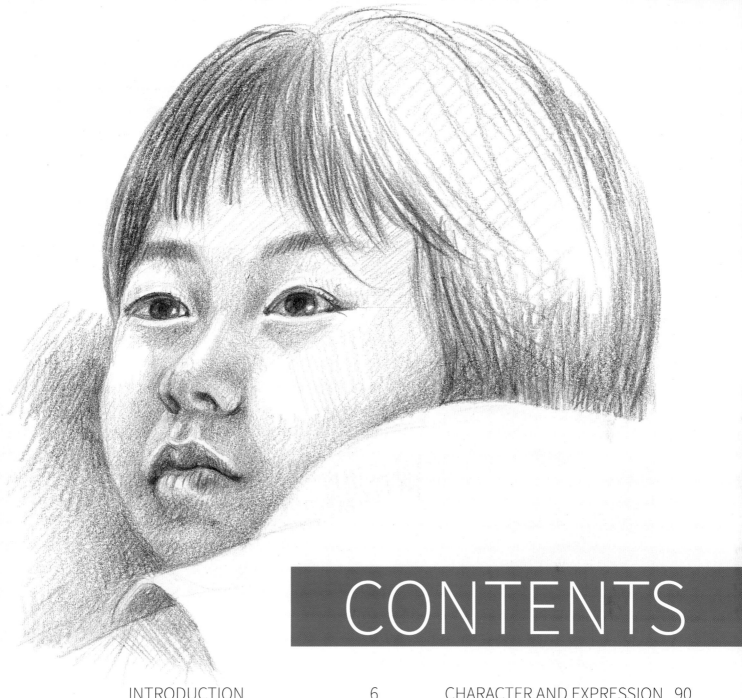

CONTENTS

INTRODUCTION

My interest in portraits began over thirty years ago when I was encouraged by a friend to attend evening classes. Although I had done a lot of life drawing at art school, portraiture was not included and I found the experience of drawing and painting from life tough yet intriguing. Since then I have produced many portrait commissions in pencil, charcoal, ink, pastel acrylics and oils.

Whether young or old, the human face continues to challenge and captivate. It is probably the most demanding of drawing disciplines yet, for me, the most gratifying. Those who have the ability to draw a portrait or achieve a convincing likeness are often perceived as having a special talent. However, I believe it is really a question of how you see, as much as what you see. It is simply a question of training your brain to translate the information from the eye faithfully onto a suitable surface; seeing and analysing the head in terms of abstract shapes, angles and patterns.

Without help or direction, a child's natural instinct is to draw their immediate environment and the people most important to them. Invariably those early scribblings are intuitive creations, not attempts at a likeness but symbolic representations – and that is how we all started. The portraits we expect to produce in later life are far from these naïve beginnings: drawing the complex shapes and angles of the head, learning the disciplines of perspective, creating light and shade and grasping the importance of negative shapes – all take time, guidance, experience... and, perhaps most importantly, practice.

Although working from life is the best way to understand the character and personality of your sitter, adding an extra vitality to your work, it is not always practical. When you begin drawing portraits, working from photographs is easier, as the image has already been reduced to two dimensions. Try to work from your own photographs – this way you will have met your model, and not only know something of their character but see their colouring more clearly. When you have gained confidence, you can try to work from life, as it is really good practice. Both approaches are addressed in this book. Many of the examples in this book have been created using my own photographs, others are sketches done from life.

After discussing various drawing media - ranging from graphite to pastel pencils – we move on to methods for shading, how to tackle individual features and how to measure proportions to achieve a likeness. We look at the characteristics of adults' and children's faces from around the world; and there are many examples of how to draw hair, facial hair and clothing, composition, pose and lighting. Some portraits are quick sketches while others are more considered, demonstrating the many ways to approach a portrait. Throughout, there are also step-by-step demonstrations for you to follow. I hope you will be inspired by this book and come to share my enthusiasm for this stimulating subject.

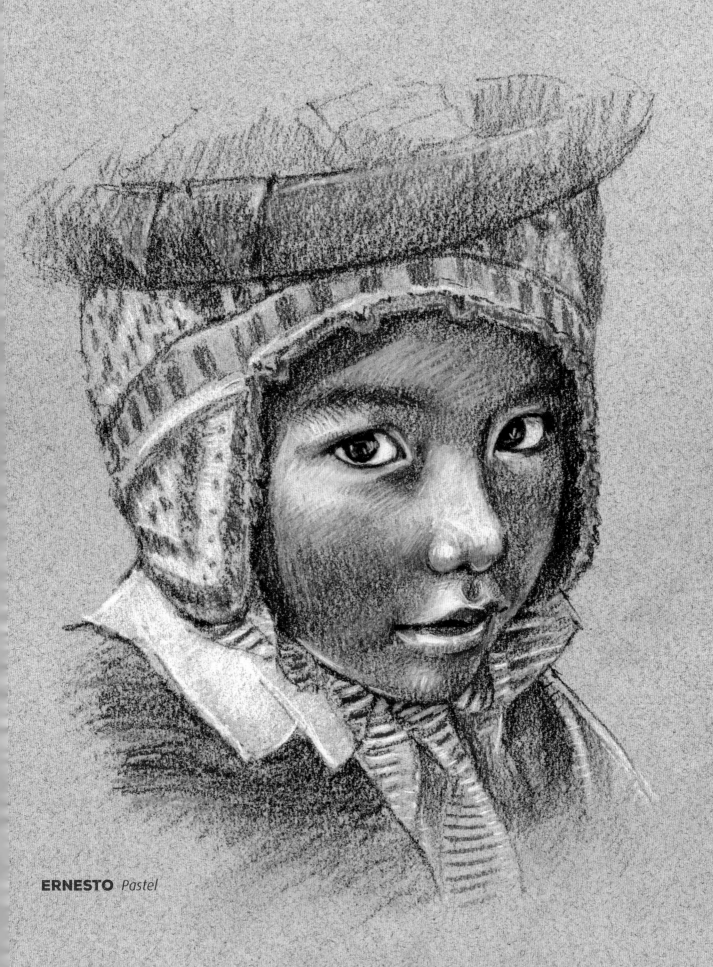

ERNESTO *Pastel*

MATERIALS

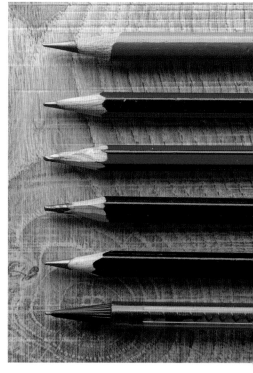

GRAPHITE PENCILS

Graphite pencils are the most frequently used, economical and readily available drawing medium. Made of a graphite core encased in a wooden shaft, they are available in a wide variety of shapes, sizes and degrees of hardness or softness, ranging from 9H (very hard) to 9B (very soft). The choice of style and softness will depend on personal preference. For portrait work, I generally use a range from B to 4B.

The softer the graphite, the blacker and more smudgeable it is. This can be an advantage if you wish to create a soft midtone, but the technique should be used sparingly; ideally we should be aiming for a variety of techniques. The softer pencils can lose their point easily, so remember to keep sharpening them, either with a pencil sharpener or knife.

To create a fine line, hold the pencil in a natural writing position so that only the point touches the paper. Alternatively, hold the pencil by the shaft to allow the side of the graphite to touch the paper, which creates a broader, more diffuse coverage.

The examples below show a variety of marks that can be achieved with the pencils illustrated. Practise making your own marks before you start drawing.

Top to bottom: 2B, 3B, 4B, 5B and 9B graphite pencils, propelling pencil.

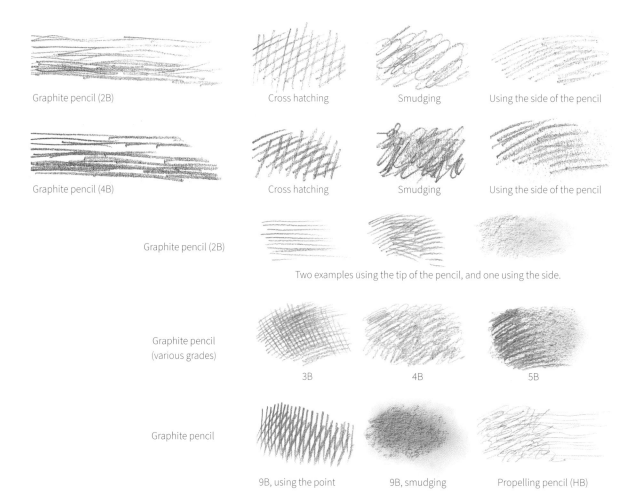

Graphite pencil (2B)

Cross hatching

Smudging

Using the side of the pencil

Graphite pencil (4B)

Cross hatching

Smudging

Using the side of the pencil

Graphite pencil (2B)

Two examples using the tip of the pencil, and one using the side.

Graphite pencil (various grades)

3B

4B

5B

Graphite pencil

9B, using the point

9B, smudging

Propelling pencil (HB)

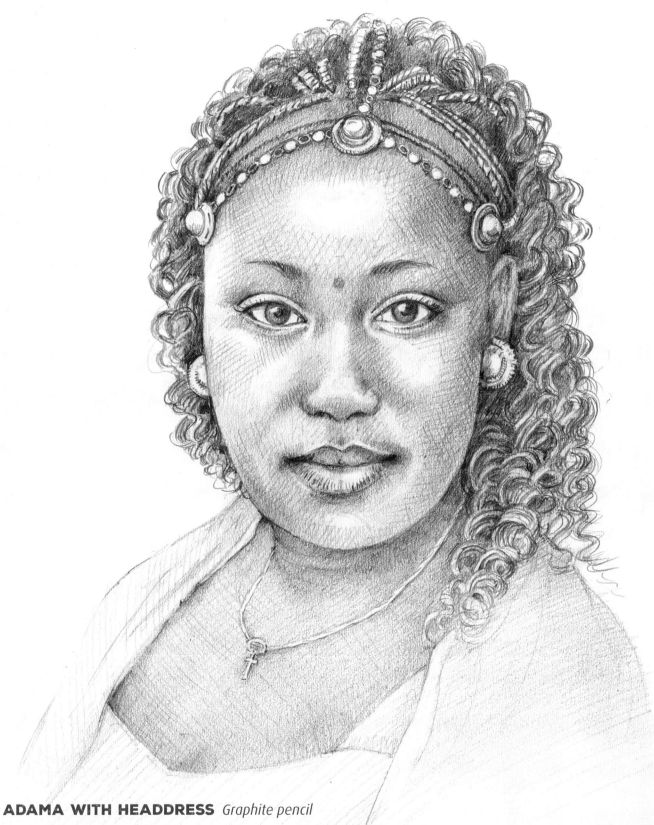

ADAMA WITH HEADDRESS *Graphite pencil*

I used a 2B pencil to do most of the drawing, switching to my 4B to create the dark areas in the hair, the eyes and round the mouth. I used a kneadable eraser to lift out the lighter parts on the skin and my electric eraser for the sharp highlights in the eyes, ringlets of hair and parts of Adama's headdress and earrings.

WATERSOLUBLE PENCILS

Watersoluble pencils, distinguishable from coloured pencils or graphite pencils by a brush or water drop symbol on the shaft, are a very versatile medium. They can be used dry, mixed with other coloured pencils, or when water is added, they transform into watercolours. Once dry, a wash will be permanent and you can add more dry layers, or more washes, building up depth and tone. They are portable, ideal for travelling or painting outdoors. Colours can change from dry to wet so always test them out before using on your painting.

Watersoluble graphite pencils or crayons are also useful for creating tones without the need to hatch and cross hatch. If you plan to use a lot of water with them, it is advisable to work on a watercolour paper of 300gsm (140lb) weight or similar, as this will resist cockling. Ideally, you should use watercolour brushes; preferably sable/synthetic mixed, as these have more strength for blending pigments with water. A water brush, which has a refillable cartridge, is very handy for using outdoors.

There are many manufacturers that produce an excellent range of colours. Try to buy artist quality as these will produce higher quality, stronger pigments.

Top to bottom: Caran d'ache Technalo (dark phthalocyanine green); Caran d'ache Supracolour (cobalt blue); Graphitone; Derwent Inktense (Lagoon); waterbrush; paintbrush.

Caran d'Ache Technalo These tinted graphite pencils are ideal for a monochrome study. They are available in a range of tints.

Caran d'Ache Supracolour An extensive range of high quality, lightfast colours, easily identifiable by their coloured shafts.

Graphitone Watersoluble graphite in the form of a crayon which gives broader coverage. Available in light (HB), medium (4B) and dark (9B).

Derwent Inktense These are inks in pencil form, making all the colours bright and transparent.

Waterbrush This has a refillable cartridge to contain water, with a nylon brush tip. It is available in different sizes and shapes. It is useful for painting outdoors, as it eliminates the need to carry a separate water bottle.

Paintbrush This is a sable/synthetic mix brush, size 10, round. I recommend using as large a brush as possible as this will hold plenty of water while maintaining a fine point.

Used dry.

Water added, then, once dry, more colour added dry on top.

Two colours together, then wetted, some totally, some partly.

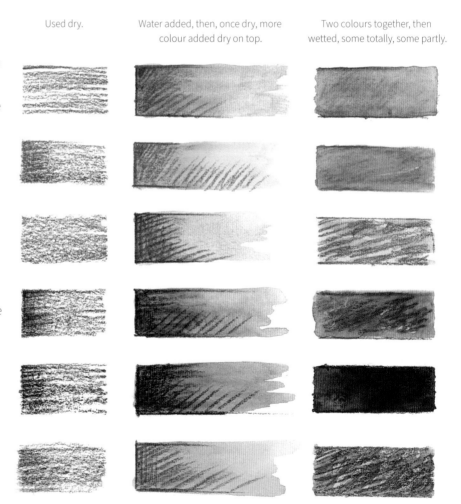

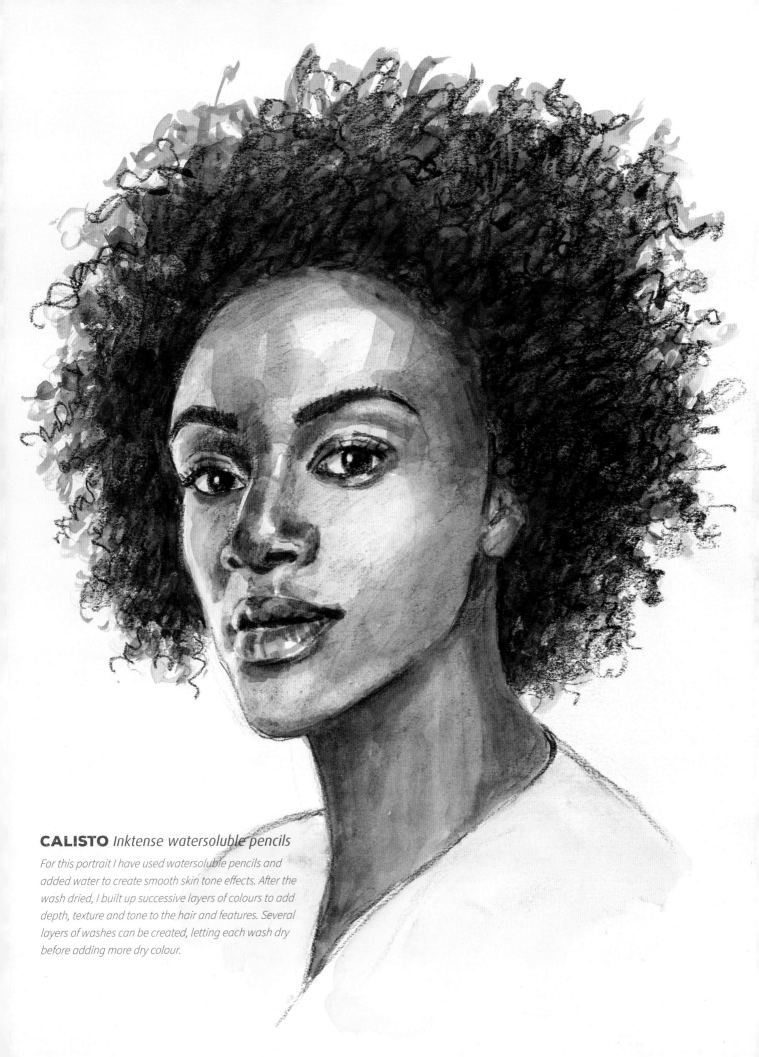

CALISTO *Inktense watersoluble pencils*

For this portrait I have used watersoluble pencils and added water to create smooth skin tone effects. After the wash dried, I built up successive layers of colours to add depth, texture and tone to the hair and features. Several layers of washes can be created, letting each wash dry before adding more dry colour.

DRY COLOURED PENCILS

Coloured pencils are produced in a great range of colours by a variety of manufacturers. As with other products, try to buy the best quality you can afford; cheaper makes contain a lower proportion of pigment and consequently are less vivid and not so effective in use. Coloured pencils are a clean medium and multiple layers can be overlaid to create depth of colour and tone. They can be burnished for a more solid effect and can be erased with a hard eraser.

Pastel pencils can be used for preparatory drawing for soft pastels, or as a medium on their own. The degree of hardness varies with different makes, and in general they are a more malleable medium than other coloured pencils with the finished result being softer. I like to use pastel pencils for short studies from life as well as for longer studies. Colours can be blended with a tortillon (see page 24), a cotton bud or a finger. Protect finished areas with a sheet of paper to prevent smudging whilst working.

Top to bottom: Caran d'Ache Luminance; Derwent Procolour; Derwent Coloursoft; Derwent pastel; tortillon (stump).

Caran d'Ache Luminance High quality, intense, lightfast colours within a natural wood shaft, available in a wide range of colours.

Derwent Procolour A good range of colours, which perform well. Here, dark blue has been added to the light blue.

Derwent Coloursoft A large range of colours, very nice to use and easily layered and blended. In the examples here, I have made lines of varying pressure, and also used the pencil on its side.

Derwent pastel pencil A softer pencil compared to other makes, which overlays and blends easily.

Caran d'Ache Luminance

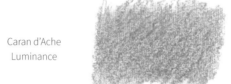

Solid colour.

Pencil used on its side.

Derwent Procolour

Area of light blue worked into dark blue.

LIght blue blended into dark blue.

Derwent Coloursoft

Marks made with the tip of the pencil.

Pencil used on its side.

Derwent pastel pencil

Derwent pastel pencil blended with tortillon (see page 24). An example of four colours blended together.

The pencil used on its side and blended into the paper.

Marks made with the tip of the pencil.

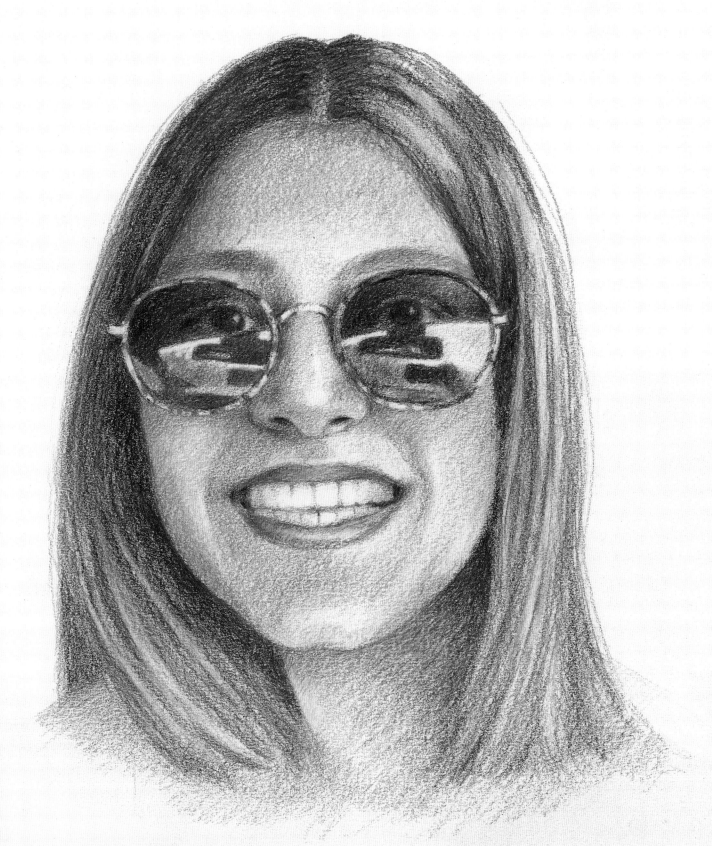

DIL IN SUNGLASSES *Derwent Procolour and Caran d'Ache Luminance pencils*

*I like the effect of just being able to see Dil's eyes through her sunglasses. I drew the majority of this portrait
with only six colours – cream, blush pink, ochre, terracotta, earth brown and black, then added Prussian blue
in the hair and royal purple in the shadows as well as permanent red and grey for specific accents elsewhere.
I used a blender pencil to create a more solid effect round the hairline, across the glasses and where I wanted
a smoother finish. Fine highlights were created with an electric eraser.*

SOFT PASTELS

Soft pastels are powdered pigments mixed with chalk and a binder. The best quality have less binder resulting in a brighter, more intense colour. Alternatively, hard pastels contain more binder and have a finer consistency; being less crumbly they can be sharpened to a point. Different types of soft pastels (and pastel pencils) can be mixed; in general, use the harder ones first, finishing with the softer types. The colour of pastels does not change from stick to paper and they are lightfast. Though messy, pastels are fun to use and effects can be achieved quickly whilst mistakes can be corrected, brushed out or reworked. They can be easily blended and it is advisable to cover finished work (with tissue paper or similar) to prevent smudging.

 Most of the pastel portraits in this book have been painted with my favourite pastels – Unison and Sennelier, shown above/right. These are artist quality and have a vast range of rich, vibrant colours from the palest delicate shades to intense darks.

Top to bottom: Sennelier pastels; Unison pastels.

Using the end of the stick.

Using the pastel on its side; the right-hand part has been blended.

Using the end of the stick.

Using the pastel on its side; the right-hand part has been blended.

Pastels used broadside, then smudged – note the more solid effect on this textured paper.

Two colours partly blended

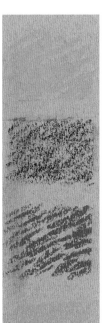

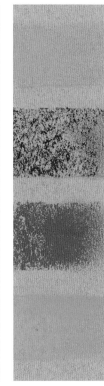

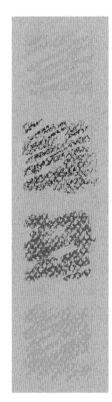

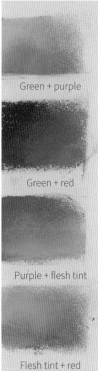

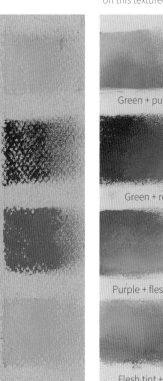

Green + purple

Green + red

Purple + flesh tint

Flesh tint + red

Canson Mi-Teintes pastel paper, Moonstone, smooth side

Canson Mi-Teintes pastel paper, Blue-grey, rough side

Sand textured paper, Art Spectrum Colourfix, Cream

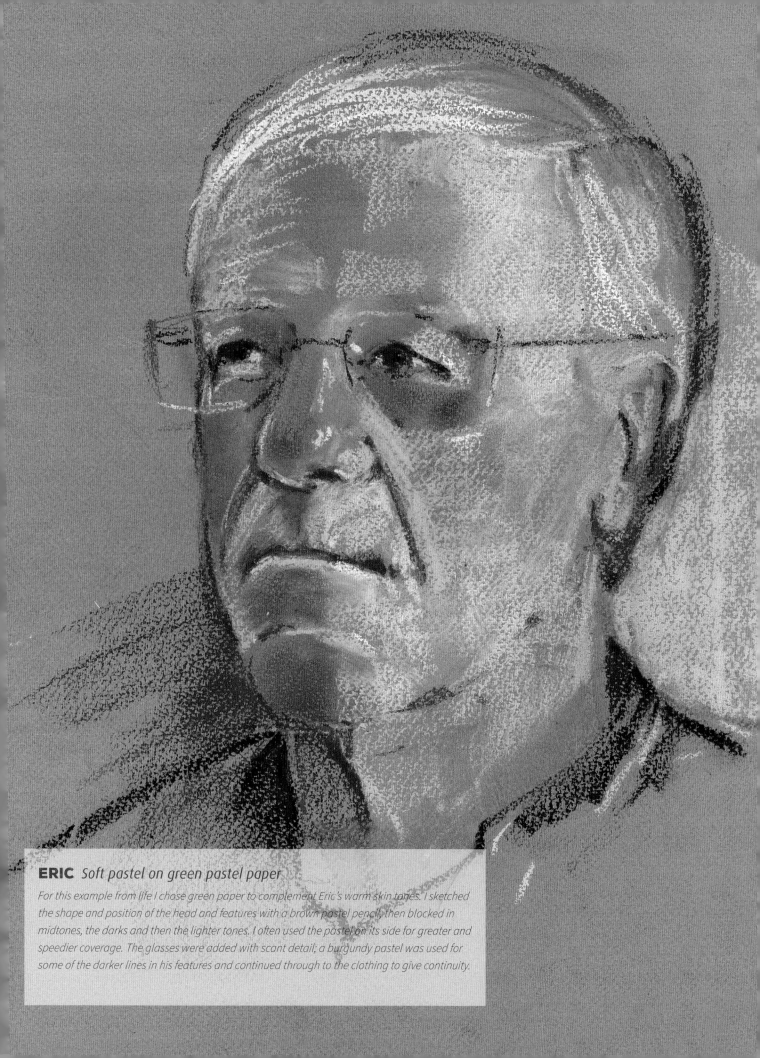

ERIC *Soft pastel on green pastel paper*

For this example from life I chose green paper to complement Eric's warm skin tones. I sketched the shape and position of the head and features with a brown pastel pencil, then blocked in midtones, the darks and then the lighter tones. I often used the pastel on its side for greater and speedier coverage. The glasses were added with scant detail; a burgundy pastel was used for some of the darker lines in his features and continued through to the clothing to give continuity.

CHARCOAL AND RELATED MEDIA

Charcoal pencil These provide a more convenient, cleaner way to use charcoal. They are available in varying degrees of dark greys and blacks.

Carbon pencil These are made from a mix of charcoal and graphite.

White pastel pencil These can be used for adding highlights on tinted pastel papers. When working on tinted paper, to keep the white highlights bright, put them in first before working with charcoal or pastel.

Willow charcoal (Not pictured) This is a traditional medium produced by the slow burning of wood to create pure, natural sticks available in widths from 2mm (⅟₁₆in) to more than 10mm (⅜in). Fine lines can be produced using the tip of the stick while broad sections can be blocked in using the side. It can be blended or smudged effectively with a finger, tissue, cotton bud or tortillon to create a wide range of tones. Highlights can be lifted out easily with a kneadable eraser.

Compressed charcoal (Not pictured) This is less smudgy than willow charcoal and is available in both stick and pencil form in a variety of grades. I prefer the stick form which delivers a rich, intense black.

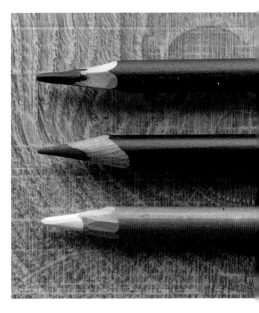

Top to bottom: light charcoal pencil, dark charcoal pencil, white pastel pencil.

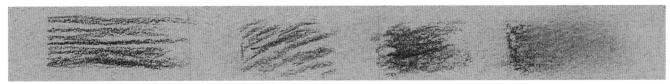

Light charcoal pencil

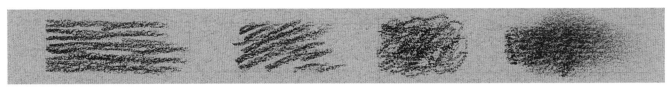

Dark charcoal pencil

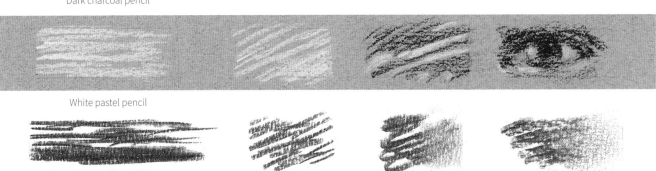

White pastel pencil

2mm (⅟₁₆in) Willow charcoal

6mm (¼in) Willow charcoal

Compressed charcoal

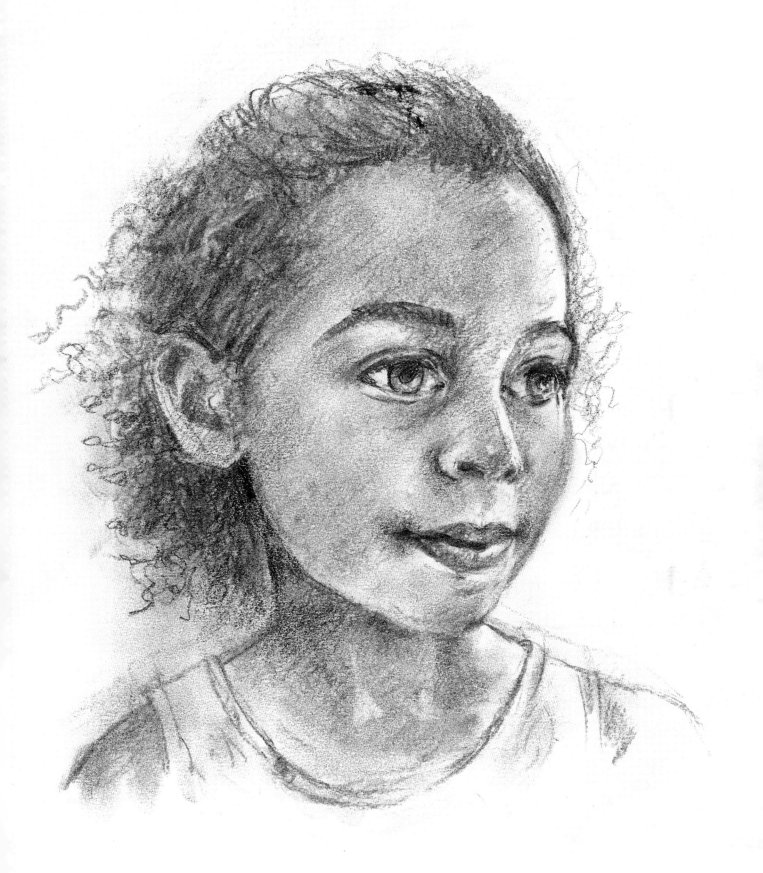

ELLIS *Charcoal on medium surface cartridge paper*

First I covered the area of the head and neck with the side of a charcoal stick, smudging it in with my hand (or a tissue) to create a mid-grey tone. Then I sketched in the features, head and hair. I lifted out the highlights with a kneadable eraser, shaped to a point, finally working in more detailing and darks where needed.

PEN

Pen produces a clean, permanent mark. Tones are created using a series of parallel (hatching and cross hatching) or curved lines, dots, scribbles or other suitable marks. A smooth or medium surface paper is therefore best for pen work. Because you cannot erase these marks, using pen can be a bit scary. However, a deliberate, indelible mark can create a more lively and dramatic drawing.

Dip pen The nibs of dip pens are made in a range of shapes and sizes which are fitted into a holder and used with Indian ink, for example. The mark produced has character and variation, thickening as more pressure is applied to the nib.

Fibre-tipped pen These are clean to use and produce a line of constant width. I prefer using 0.2–0.8mm for portrait work. Most fibre-tipped pens are permanent but some are watersoluble.

Brush pen These have a nylon or fibre brush which is supplied with a constant flow of ink from the cartridge. A wide range of brush-like marks can be achieved from very fine to thick.

Watersoluble pen These can be bought as double-ended pens, one end a fibre tip, the other a brush tip. When water is added, the ink dissolves to produce interesting, irregular effects. The ink is permanent when dry.

Other pens Ballpoint, fountain and calligraphic pens are also suitable for drawing portraits, depending on your own preferences.

Top to bottom: dip pen; Faber-Castell F (0.8mm) fibre-tipped pen; Uni Pin 0.2mm fibre-tipped pen; Pentel brush pen; Biro ballpoint pen; Kuretake watersoluble double-ended brush pen.

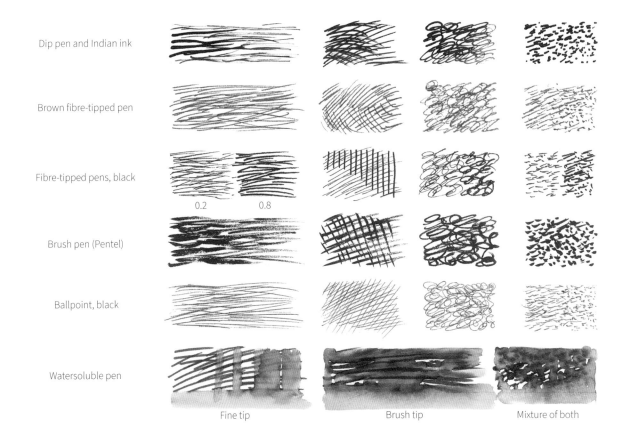

Dip pen and Indian ink

Brown fibre-tipped pen

Fibre-tipped pens, black

0.2 0.8

Brush pen (Pentel)

Ballpoint, black

Watersoluble pen

Fine tip Brush tip Mixture of both

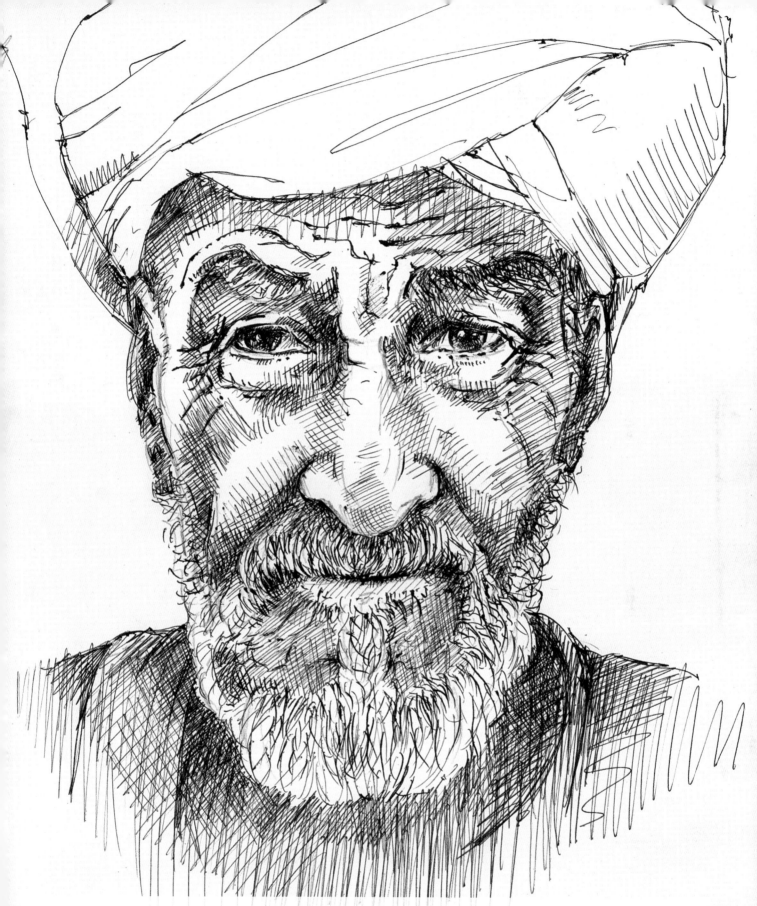

JEROME *Dip pen and ink*

I enjoyed creating a freehand drawing with my dip pen, building the form, shading and texture using hatching, cross hatching and a variety of expressive marks to portray this interesting, well-worn face.

I was so eager to start, I placed the head too high on the paper, cropping off the top of his turban, but now it's finished I think this composition emphasizes his piercing gaze.

SURFACES

A wide variety of papers suitable for drawing is available. Inevitably it comes down to a matter of personal choice.

Cartridge paper This is made in a range of finishes and weights. For pencil and charcoal, the paper needs to have a texture with a slight 'tooth'. The weight is measured in grams per square metre (gsm) or pounds (lb). I prefer to use medium surface paper of at least 150gsm (90lb) weight, which is suitable for pencil, charcoal or pen, and will also withstand a light wash. Rough surfaces give a broken effect and therefore are not so suitable for pen and ink unless texture is desired.

Pastel paper As well as being available in a wide range of colours, pastel papers also have 'tooth'. Some have a smooth and a rough side, and the choice of texture may depend upon your subject. For the delicate complexion of a child I would select the smooth side (see *Poppy, 15 Months*, on page 62 for an example), whereas I might decide on the rougher side to create more character for an older person (see *Glaring*, page 94). Shown are some of the colours I prefer. A midtone is most appropriate for portraiture so that both black and white pastel pencils contrast with the surface.

> ## TIP
> Before starting to work on pastel paper, check you are using the appropriate side (smooth or rough). It is not always obvious until you start to block in the tone; by then you may have already spent some time working on the 'wrong' side for your particular subject!

Sand textured paper This is one example of the many textured pastel papers available. Pastels adhere extremely well to this surface, allowing successive layers to be built up. Sand textured paper is available in a wide range of colours and some will allow water to be added. Because of the rougher surface, blending is not as easy as it is on paper.

Watercolour paper (Not) This is a semi-rough watercolour paper. The surface can be used for charcoal, pen, pencil, and watersoluble media, giving a grainy quality to the work.

Watercolour paper (Hot-pressed) Also known as HP or smooth, this paper is suitable for pencil or pen work.

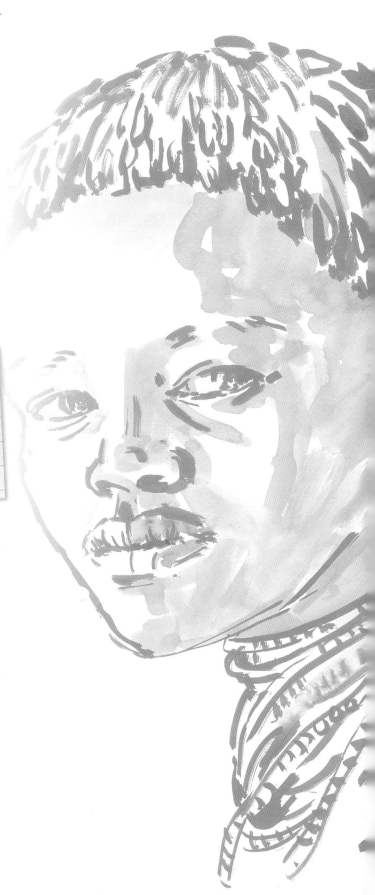

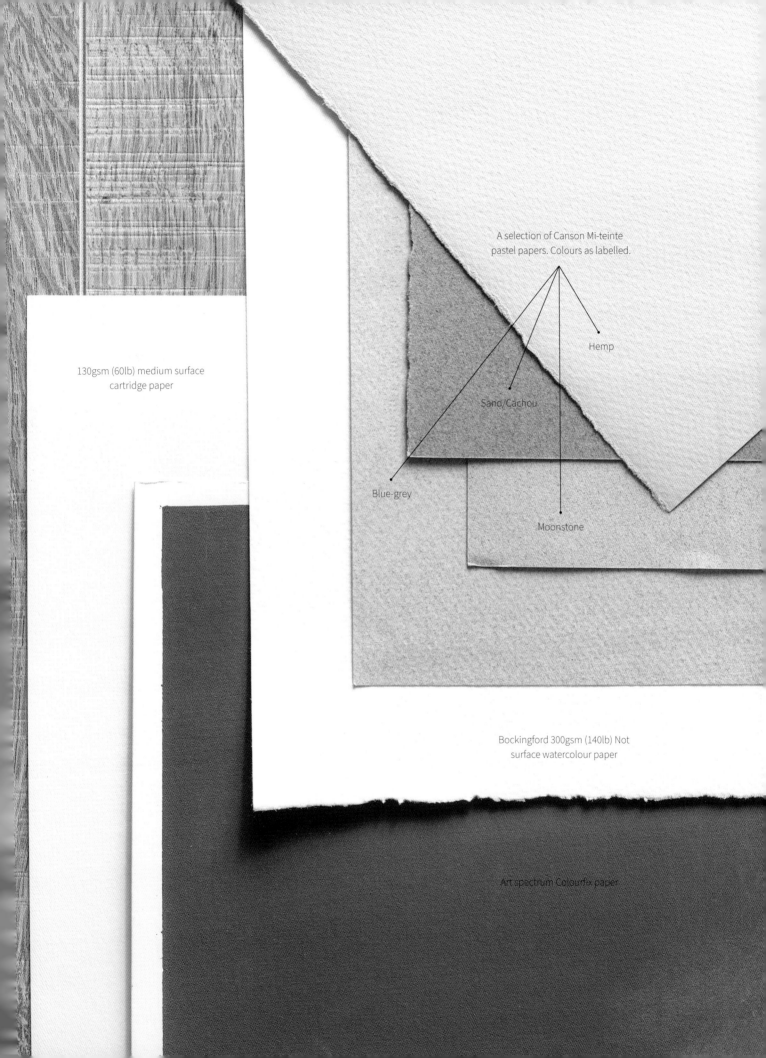

A selection of Canson Mi-teinte pastel papers. Colours as labelled.

Hemp

Sand/Cachou

Blue-grey

Moonstone

130gsm (60lb) medium surface cartridge paper

Bockingford 300gsm (140lb) Not surface watercolour paper

Art spectrum Colourfix paper

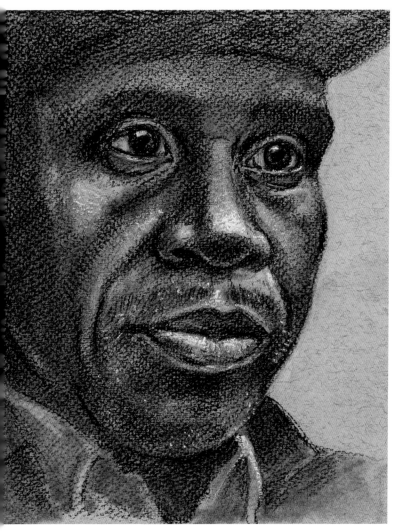

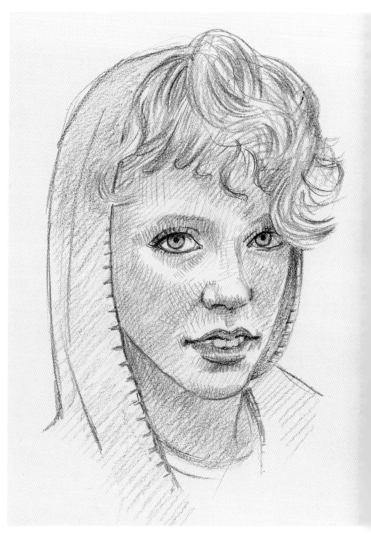

BILL *Pastel pencil on Canson Mi-Teintes, sky blue, textured side*

Having lightly drawn the features, I put in the highlights with a white pastel pencil before working up the darks. Final highlights were added with a soft pastel which had more covering power.

ERIN *Derwent Procolour pencil on W&N medium surface cartridge paper*

I drew the face and hair in a reddish-brown pencil and the clothing in grey before lightly adding the skin tones with a series of hatching and cross-hatching marks.

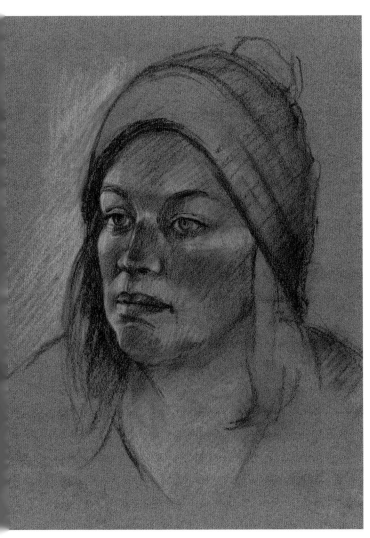

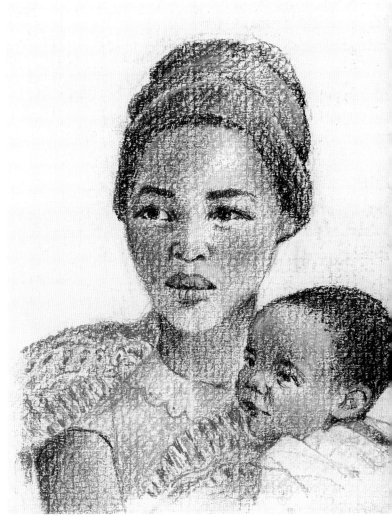

REBECCA *Pastel pencil on Canson Mi-Teintes pastel paper, smooth side*

This study was done from life. I used the colour of the paper to stand for some of the midtones, adding highlights and darks to create the form.

MOTHER AND BABY
Pastel pencil on a texture pastel paper, buff

I did several mother and child studies in preparation for this book. Although I would not normally use such a heavily textured paper for a tender subject, I thought the result reflected the mother's rather concerned look.

OTHER MATERIALS

Tracing paper This is semi-transparent paper used for tracing photographs or drawings.

Transfer paper A type of tissue paper that is impregnated with graphite on one side and used to trace down an image. I call it 'artistic carbon paper'.

Viewfinder This simple card frame is a very helpful aid to decide on the composition, whatever the subject. I often use the 50 x 75mm (2 x 3in) aperture as a template for thumbnail sketches.

Fixative Useful for helping to 'fix' charcoal or pastel. It can, however, dull highlights and will not entirely prevent smudging.

Kneadable eraser Made of soft, malleable material like putty, these erasers can be shaped to a point for erasing highlights in pencil or charcoal.

Plastic eraser Harder than kneadable erasers, these are better-suited for erasing more durable marks.

Electric eraser A surprisingly useful tool for erasing small areas in pencil or charcoal – a tiny highlight in the eyes or wisps of hair, for example.

Tortillons (stumps), cotton buds (Q-tips/swabs) Tortillons are tightly rolled paper with two pointed ends, available in a range of sizes. They are useful to blend small areas of pastel pencil, soft pastel or charcoal. When the tip becomes dirty it can be cleaned on a piece of sandpaper or sandpaper block. Cotton buds also work for blending, though they are not as fine.

Sandpaper block Very useful for honing a pencil or pastel pencils to a point between sharpenings. It can also be used for cleaning tortillons.

Craft knife A good way to sharpen pencils to a long, fine point. Not everyone finds this method easy; if you are unsure, it might be safer to use a pencil sharpener.

Pencil sharpener A manual pencil sharpener is a practical and safe alternative to using a craft knife if you have a quantity of pencils to sharpen. The Jakar sharpener below is a very useful tool in my art kit as it can sharpen to a long slim point or a more traditional point.

Ruler A metal ruler is useful for cutting if you are using a knife. I also use a plastic ruler, though I always prefer to draw straight lines freehand as this produces a less mechanical effect.

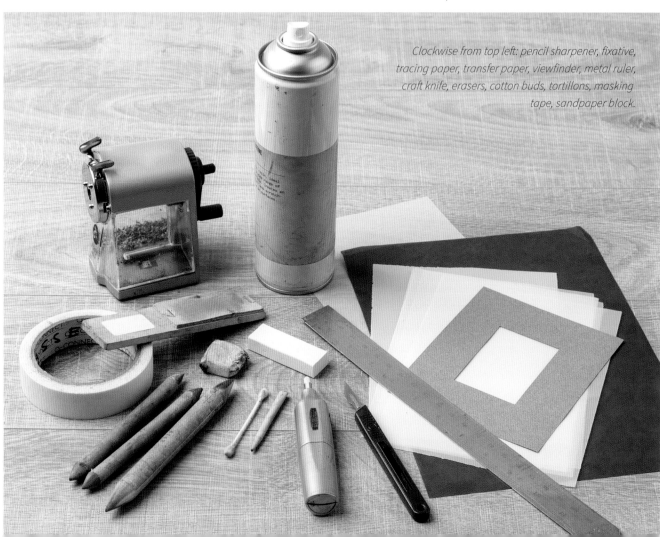

Clockwise from top left: pencil sharpener, fixative, tracing paper, transfer paper, viewfinder, metal ruler, craft knife, erasers, cotton buds, tortillons, masking tape, sandpaper block.

Drawing board A firm surface on which to draw is an essential studio item. Raise the head of the board to a comfortable working position or use it upright on an easel.

Easel A sturdy desk easel allows you to use the board upright.

Masking tape This can be used to fix your paper to the board to prevent it moving while you work.

Clips A simple and reusable way of fixing your paper to the board. These are also handy for clamping sketchbook pages down if you are sketching outside in windy conditions.

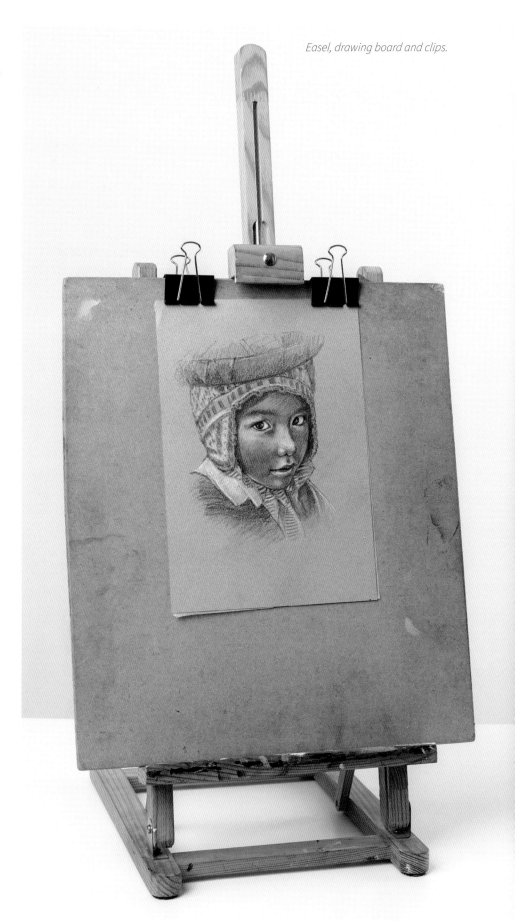

Easel, drawing board and clips.

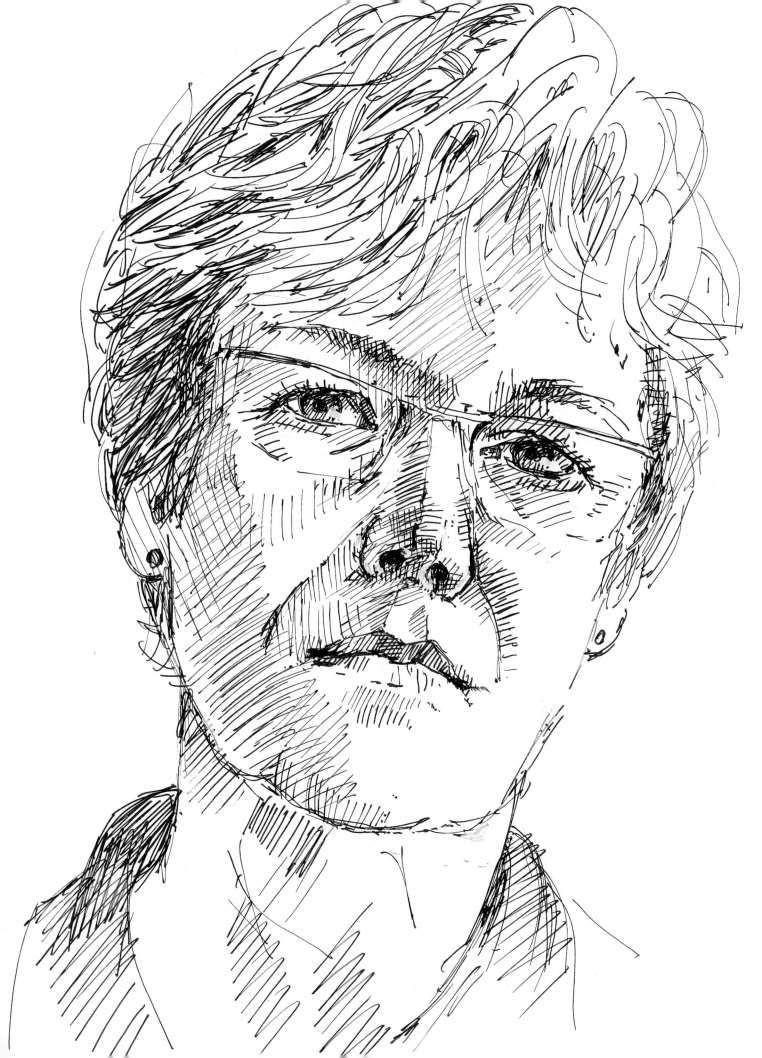

YOUR FIRST PORTRAIT

If you want to work from life but do not want to go to the trouble of hiring a model or asking someone to sit, then self-portraits are the answer. They are a very good way of gaining confidence in drawing from life. Alternatively, if you have more experience, you may want to push the boundaries and experiment with new ways of portraiture.

Many artists, past and present, have drawn and painted themselves. Rembrandt van Rijn (1606–1669), for example, painted countless self-portraits through times of affluence and poverty, from youth to old age, and they remain a permanent testament to his life and art.

My self-portrait was sketched quickly in pen, looking into a mirror. If you want to do a self-portrait as others see you, then you will need to set up two opposing mirrors to give a true representation of your 'public' face.

SELF-PORTRAIT *Fibre-tipped pen*
I drew this self-portrait quite quickly using a fibre-tipped pen, without preliminary pencil guidelines. I am concentrating hard, so look rather serious!

SELF-PORTRAIT

As you follow this step-by-step guide, your self-portrait will naturally be very different from mine, but the underlying principles are universal. Drawing oneself is an ideal opportunity to practise core skills of observation and careful measuring – and the model stays still for as long as you want!

If, like me, you are wearing glasses, try to avoid the reflections that can cut across the eyes. As you look in the mirror, it may be easier to use the reflection of the pencil for reference rather than the pencil itself – the important thing is that whichever you chose, be consistent.

Materials

- Winsor & Newton 130gsm (60lb) medium surface cartridge paper
- 3B graphite pencil
- Craft knife
- Kneadable eraser
- Electric eraser
- Table easel and drawing board
- Bulldog clips
- Mirror

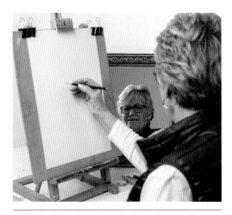

1 Set up your drawing board on the easel at a comfortable height, with the paper held in place with bulldog clips. Working upright, as shown here, makes checking angles easier. Place a mirror to the side of you. I'm right-handed, so I have it on the right-hand side.

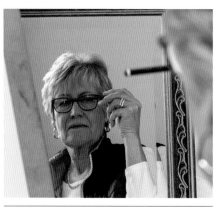

2 Begin by measuring the angle of the eyeline. Use the barrel of the pencil to check the angle against your reflection. The distance between the pupils will serve as your basic proportional guideline and help you get the general positioning correct.

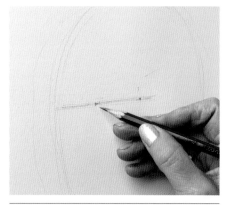

3 Bring the angle over to the paper. Draw a faint line, then mark the positions of the pupils on the line. 'Ghost in' a very faint ovoid shape as a guideline to suggest the size of the whole head. The eyeline should sit roughly half of the way down the head.

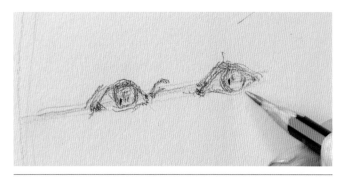

4 Pencil in one eye – note that the iris is to one side, as I am looking slightly sideways at the mirror – then draw in the other, being careful to get the distance between them right. The top lid will cut through the curve of the iris and be more arched than the lower lid. Draw these shapes lightly at first, then feel free to correct and re-draw as necessary.

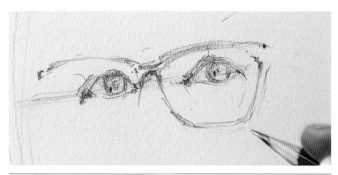

5 You can use other features to help placement. The parts of my glasses, for example, can be used as a template. By working out where parts of the frames sit, it becomes easier to work out where more subtle features, like the bridge of the nose, should be placed. Keep referring to your reflections – look more than you draw. In particular, look for negative shapes – areas of space created by being surrounded by objects, such as at the space between the top of the eye and the frame, or the side of the eye and the arm of the glasses.

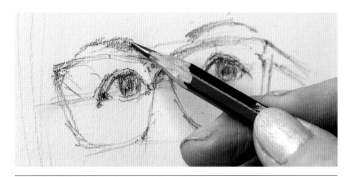

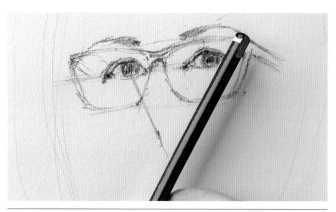

6 Begin to work outwards from the eyes. The visible arm of the glasses is very useful to give you a sense of the angles of the head. With this area established, go back and strengthen the lines with more definite marks. Add a little bit of tonal shading to the eyes with a mix of hatching and controlled scribbling marks, and use the same techniques for the eyebrows.

7 To find the position of the base of the nose, mark faint lines from each pupil to the middle of where the nose meets the plane of the face (not the tip). Double-check these lines using the barrel of the pencil.

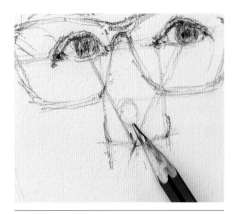

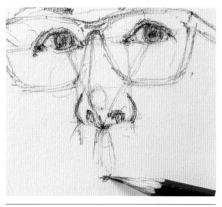

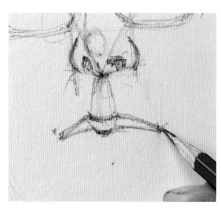

8 Work out the width of the nose by drawing vertical lines down from the eyes in line with the edges of the nostrils. Draw lines to mark the angle from the base of the nose to the nostrils, then draw a small, faint circle to mark the tip of the nose.

9 Refine the nose and draw in the nostrils, paying careful attention to their placement and shape. Lightly draw in the philtrum, and work out the distance from the base of the nose to the middle of the mouth. You can work visually, use the triangulation process (see steps 7 and 8) again, or use the established distance between the pupils to get the placement right.

10 Work outwards from this central point to mark the width of the mouth. Be aware that the distance will likely not be equal on either side, as the portrait is not full-face, but slightly turned. Draw in the top lip lightly, then use this to draw the mouth itself. Note that the line is rarely completely straight – there is usually a slight arc near the centre.

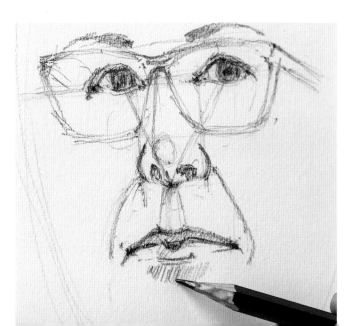

11 Use some hatching marks to add some tone to the upper lip, then add the marks from the sides of the nose to the sides of the mouth. Hatch in the lower lip. Check that the angle of the eyeline, the nostrils and the corners of the mouth are all roughly parallel.

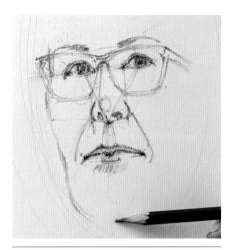

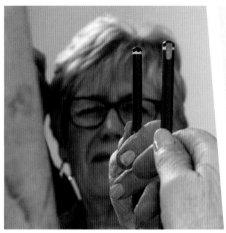

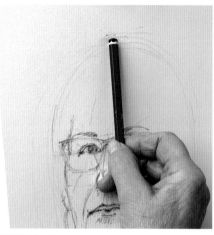

12 Returning to the eyes, establish the outline of the far side of the face. We start here because the shape is clearer and easier to see. Work down from the eyeline, sketching in the shape of the cheek. Continue round to the chin, comparing the distance from the lips to the base of the chin with another established distance on the face.

13 Next, the forehead and hairline. This can be a deceptive distance – it is often longer than you might think. Hold the tip of your pencil against with your hairline, then place your thumb where your eyeline is. Measure this against another distance (the eyes to the mouth or chin, for example), then transfer the distance to your paper to establish the hairline.

TIP

Refer to the features as you work down – what is in line with the tip of the nose? How about the base of the nose, or top of the lips? Asking such questions will help you achieve accuracy.

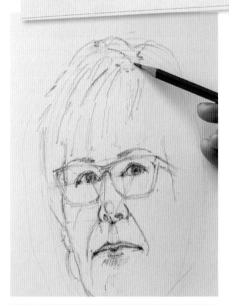

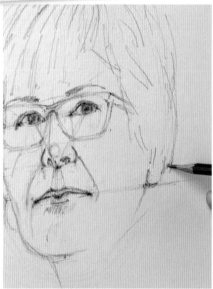

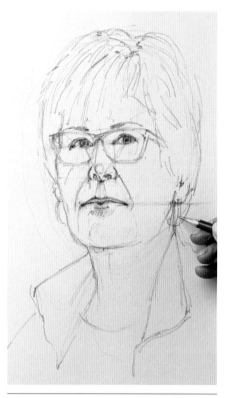

14 Use light marks to suggest the mass of hair. Don't try to draw individual hairs: look for the overall movement. Establish the width of the right-hand cheek by measuring from the nose to the ear. This is often much wider than you think!

15 Plot the base of the ear using a horizontal line to the mouth. Is it level, above or below? Use the answer to place the jawline and hair on the side of the head, working the latter upwards into the remainder of the hair.

16 Suggesting the shape of the neck and shoulders is important for likeness too, so don't neglect these areas. Work by eye, make sure the neck is the right width, and keep this area simple. Don't overcomplicate things because this will draw the viewer's focus away.

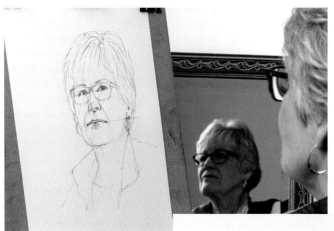

17 This completes the portrait, but don't stop just yet. Walk away for a few minutes, then come back with fresh eyes and make any fine adjustments you wish.

THE FINISHED DRAWING
Graphite pencil

Each time I do a self-portrait, the result is slightly different; indeed, this recent one which I did in the studio, with a camera over my left shoulder and the clock ticking, looks quite different from the pen portrait on page 26. In truth I feel both could be improved upon, but they are both personal pieces of work and it is the process that counts, the doing and the seeing. Getting it right next time is what spurs us all on.

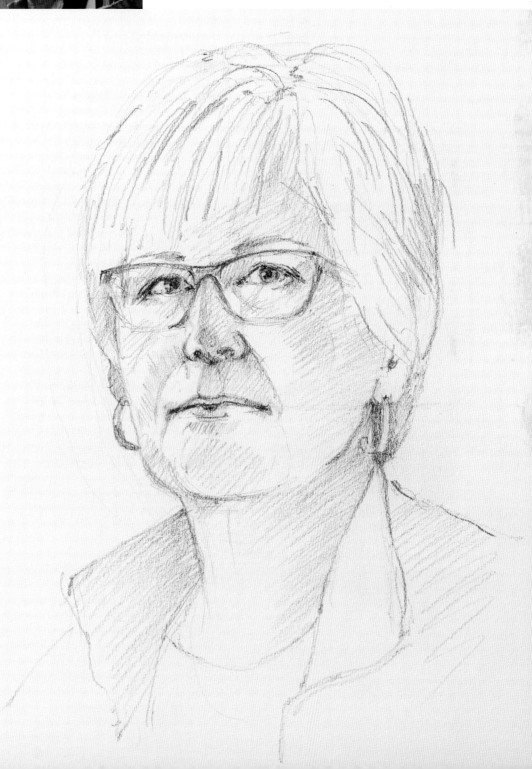

SHAPE AND STRUCTURE

No matter how well each individual feature is drawn, this will count for nothing if we have not understood the overall structure and framework. The features are an addition to this vital scaffolding. If a tree or piece of fruit is drawn slightly wrong, does it really matter much? Yet the slightest misplaced line on a portrait – an eye too big or the nose a little too short – will certainly change the look completely.

When we start drawing portraits, the tendency is to concentrate on depicting the features, as it is these, in all their complexity, that allow us to recognize people. However, if we spot a friend in the distance or through the mist we can still recognize them, even when we cannot see their features clearly: the features are secondary to the structure of the head and how the light and shadow fall across the form. The underlying bone structure is different in each individual, giving shape and form to the head. The skull determines the width and length of the head, the span of the forehead, the set of the cheekbones or the depth of the brow ridge and contour of the jawline. So before starting to draw the superficial bits, let us first consider the scaffolding!

THE SKULL

If you can study and draw the skull, you will have a much better understanding of the structure beneath the surface when you come to do a portrait. It is easy to get so engrossed with the surface features and getting a likeness that one can forget about what is underneath.

The form of the face and features depends greatly on the underlying skull and bones; knowledge and familiarity with this structure will help you understand and therefore create better portraits.

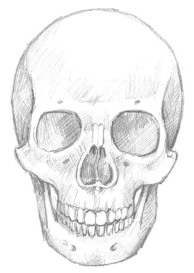
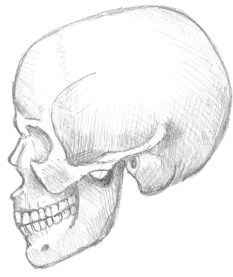

Viewed from the front, the skull is roughly an ovoid shape (left); in profile it is a 'D' shape (right). The top of the eye sockets give form to the eyebrows, and their lower rims define the cheekbones; the outer edges of the eye sockets mark the near right-angle turn to the side of the head and temples (see Box Shapes on page 34). The teeth delineate the shape of the mouth and lips.

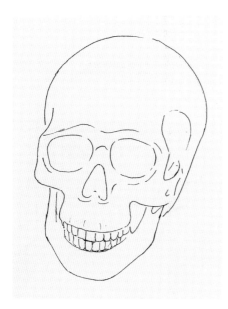

The skull, slightly rotated to the left.

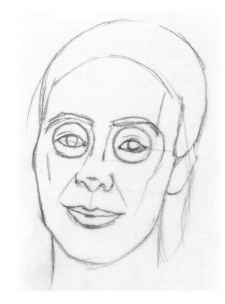

*The skull is reduced to an outline, onto which
I have started to build the features.*

SKULL AND HEAD

This is a hypothetical example of a
drawing from skull to finished portrait,
as I obviously couldn't use a real life
example! It shows how the underlying
scaffolding of the skull gives shape and
form to the features and the head.

*The drawing of the features without the
skull outline.*

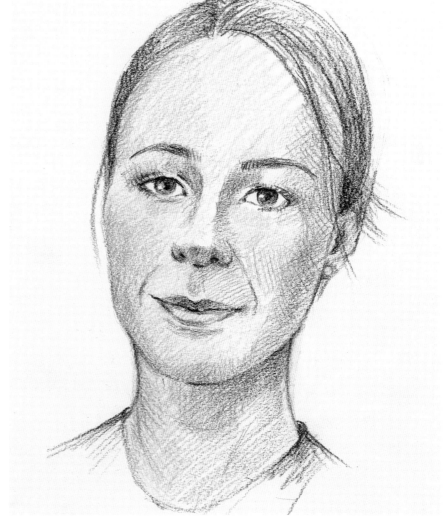

THE FINISHED PORTRAIT
Coloured pencil

*'Fleshed out' with colour, light and shade, we
have a portrait of a real person!*

BOX SHAPES

The usual way to start drawing a head, particularly from a straight-on view, is to sketch an ovoid shape, but after looking at the skull we can see that the head, seen from a three-quarter view, also has a distinctive box-like structure with a front, two sides and a top.

Viewing the head as a cube serves to show us the noticeable turn of plane from the forehead to the temple, from the cheek to the side of the face, thereby helping us to draw the head in perspective. The examples below illustrate how abstracting the head to a simple box can help with accuracy and positioning.

It may seem rather strange to interpret the rounded contours of the human head in terms of a cuboid and flat planes, but any method that helps us analyse the complex three-dimensional shape of the head is good for both the beginner and more experienced artist alike. Once you become familiar with looking at the head in this way, and your understanding increases, it becomes an *aide-mémoire* rather than something you have to do each time you draw a portrait.

Seeing a three-quarter-view head encased in a snugly fitting box helps to distinguish between the frontal plane, where most of the features are positioned, and the side of the head comprising the temple, side of the cheek and ear and so forth. This method of analysis also helps to define where the lights and darks should sit.

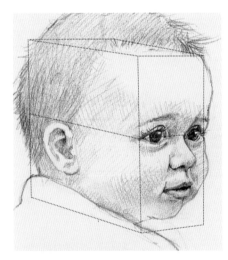
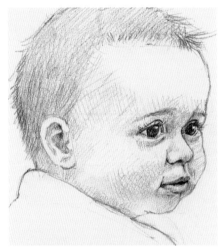

BABY *Graphite pencil*

It is surprising what a relatively small area the features occupy in comparison to the rest of the head, clearly illustrated in this drawing of a baby.

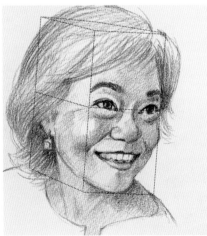
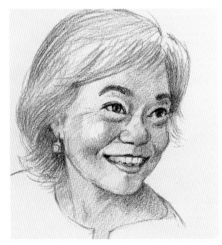

ELLEN *Coloured pencil*

Here, the head is rotated to the right and tipped slightly downwards, with the light source illuminating the left-hand side of the head.

THE SKULL AND THE FACE

Because of the relatively thin covering of soft tissue and muscles, facial features are very much dictated by the shape of the eye sockets, the brow ridge, the cheekbones, the jaw and the teeth.

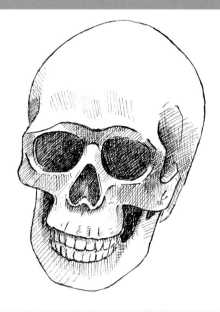

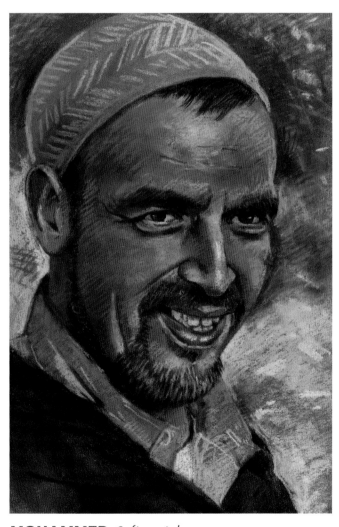

MOHAMMED *Soft pastel*

Strong sunlight illuminates the front of Mohammed's head, with the temples, sides of the cheek and ear in shadow. His head is slightly slanting down; if we had drawn a box we would see the top plane of it.

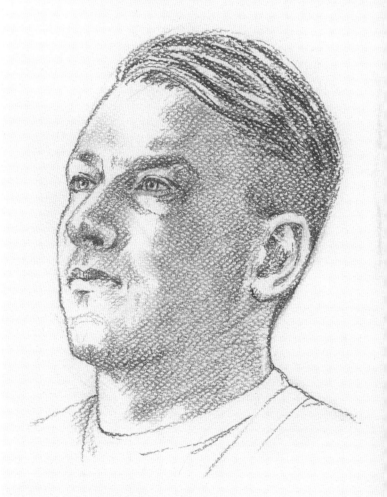

RUGBY PLAYER *Charcoal pencil*

A simpler, tonal drawing of the head slightly tilted upwards. The side of the nose and side of the head are in shadow whilst his ear, which juts out a little, just catches the light.

PLANES OF THE HEAD

Having imagined the head within a box shape to identify the change from the front to the side of the head, the analytical approach can be taken further by imagining that the entire face is made up of small flat plates, each contour and rounded outline being squared off, segmented into flat angular planes. This is very helpful in evaluating the shapes of the negative spaces – the forehead, the cheeks, the upper lip area, the chin and the sides of the head, for example, and also how light and shadows fall across the form.

Rashmi

In these drawings I have emphasized the construction lines which show each change of angle on the surface of the face. Although not aimed at realism, deconstructing the head in this way is a very useful way of simplifying the form, identifying each change of direction in the planes of the head, and helping in analysing the overall structure.

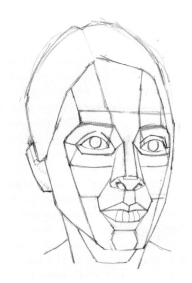

1 I started by simplifying the shape and form of the face, dividing it into angled planes.

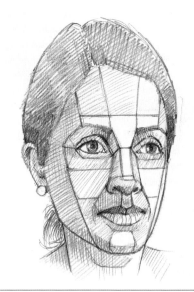

2 The second stage is to add shading to help define the shadows and highlights.

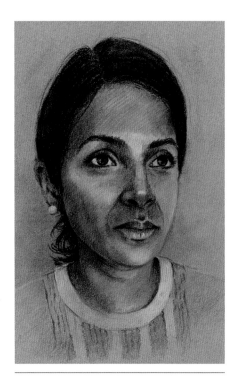

3 Now I have rounded the sharp angles. This analysis has helped me to evaluate the underlying bone structure and the areas of light and shade on Rashmi's head.

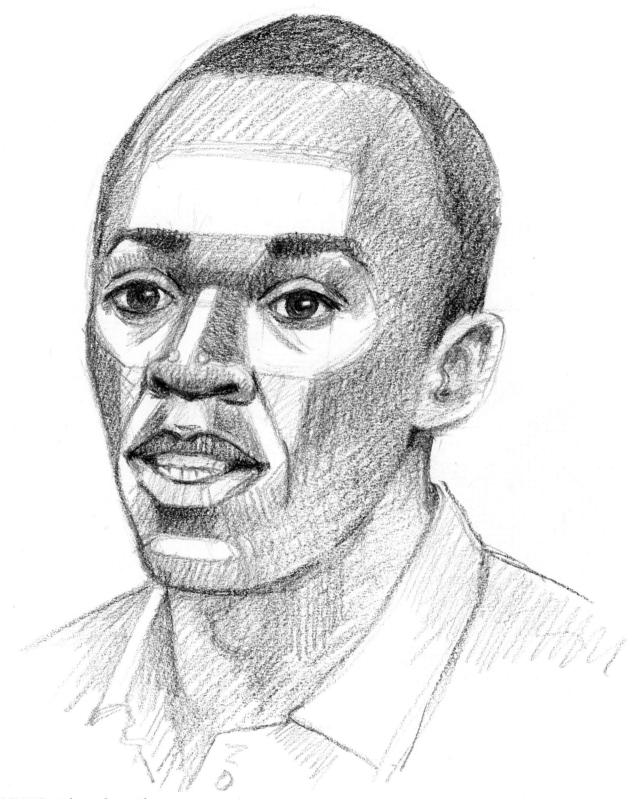

DARIUS *Coloured pencil*

*There is a strong contrast between the light and dark planes on the head. Those planes that
tilt upwards – the forehead, upper cheeks, upper lip, lower lip and part of the chin catch the
light, emphasizing the three-dimensional form of the head.*

FEATURES

This section examines the characteristics of each facial feature in detail. We look at the eyes, nose, mouth and ears in turn, and at different age groups and ethnic origins. Studying individual features closely will help you become more confident when you tackle a full portrait.

EYES AND EYEBROWS

It is often said that the eyes are the window to the soul; they are perhaps the most expressive feature and certainly what we look at first in another person. One person's eyeballs are very similar to another's apart from the differences in the colour of the iris. It is the shape and the way they are set in the eye socket, the depth of the eyelids and the lashes that account for such a huge variety. The shape and symmetry also changes depending on the view and where the eyes are looking.

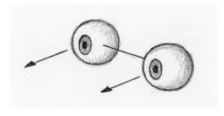

Always draw the spheres of the eyeballs in pairs to avoid a squint.

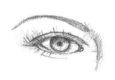

Women's eyes often have long thick lashes whilst the eyebrows can be arched.

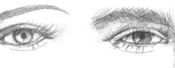

A man's eyebrows are usually heavier and thicker than a woman's.

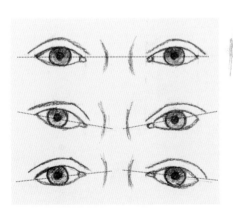

The upper lid is more curved (and more mobile) than the lower lid. The eyes can slope slightly up or down, corner to tear duct.

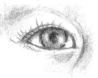

A child's eyes are the same size as an adult's but appear larger because of the smaller frame; they are also usually wider apart than an adult's eyes, in proportion to the rest of the face.

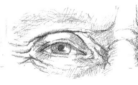

In older faces, the top lid can often sag and there are often 'character lines' radiating from the corners of the eyes. The eyebrows are often thicker or uneven. The eyelids thicken with age and less of the 'white' of the eye can be seen.

EXERCISE

Using a mirror, practise drawing your own eyes in various positions and from different viewpoints, noting how much the shape of the spheres and the eyelids change.

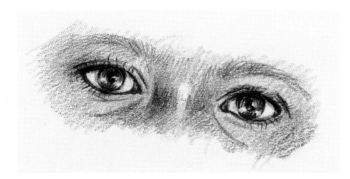

LIGHT AND SHADOW *Coloured pencil*

Highlights may come from several light sources and can add a real sparkle to the portrait. When adding a highlight, avoid the pinpoint of light in the centre of the pupil that often appears when a photograph is taken with a flash. A small highlight across the iris is usually all that is required.

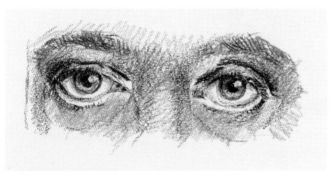

OLDER EYES *Coloured pencil*

There is a thickness to the lids, with a shadow cast from the top lid across the eyeball. The lids thicken with age and the bottom lid, which faces upwards, often catches the light.

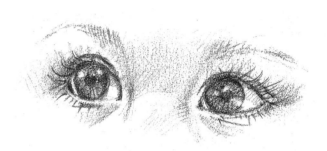

POSITION OF THE PUPILS *Graphite pencil*

The pupils always appear in the centre of the iris even when seen from a side or three-quarter view. Note that the eyelashes spring from the edge of the lid.

Three-quarter view

This view of the eyes in perspective means the shape of each one is different and the irises and pupils are elliptical. When drawing in the eyebrows, bear in mind that the more distant one will appear shorter and more rounded than the nearer, owing to the angle.

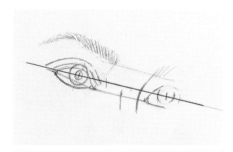

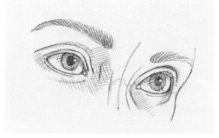

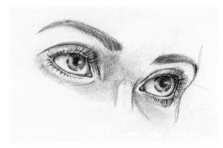

1 Start by drawing the eyeline – a line through the pupils, then lightly add the complete ellipse of the left-hand iris before drawing the lid. Measure the distance between the tear ducts by comparing it to the width of the eye, and make sure the tear ducts are parallel to the eyeline. Draw in the bridge of the nose to give you marker points to help calculate the distance.

2 Add more detail and erase the top of the iris where it goes under the top lid. Redraw or strengthen where necessary.

3 Add shading, then use an eraser (kneadable or electric) to lift out the highlights. Note that there is often shadow right across the brow, with the forehead and central band of the nose remaining relatively lighter.

NOSES

The nose can vary more than any other feature and is also the most prominent feature; as such it casts a shadow – something that we often shy away from rendering truthfully.

The upper half of the nose is shaped by the nasal bone whereas the lower half is formed by cartilage and tissue and is more malleable. The septum is the tissue between the nostrils, and the philtrum joins the septum to the middle of the lips. Highlights and shadows describe its shape better than drawn lines, whilst the shadow underneath indicates how far it projects. The slightest change of viewpoint will alter its shape.

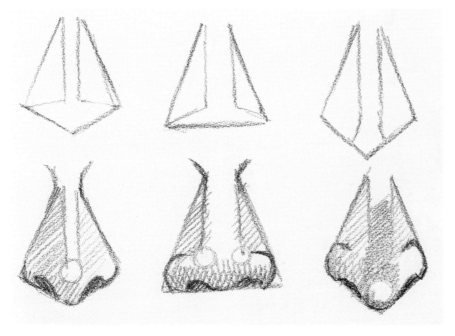

Structure of the nose

In essence, the nose is one triangle on top of another. The three top diagrams (see left) show the basic simplified shapes.

These simple shapes can then be developed by rounding the curves and adding highlights and shadows, as shown in the bottom row.

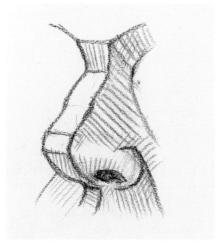

There is often a flat narrow band that runs down the middle of the nose, which can vary in width.

A child's nose lacks the strong bridge which develops as the child ages. In infants, there is no bridge at all, the nostrils being the only part of the nose that stand out.

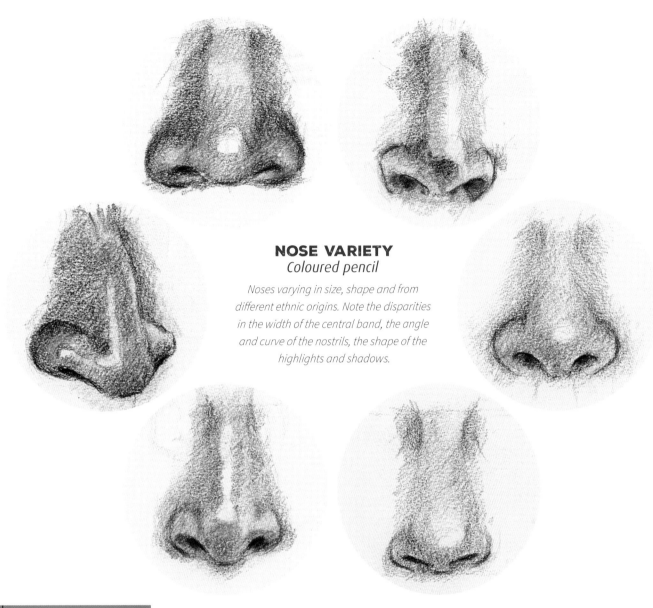

NOSE VARIETY
Coloured pencil

Noses varying in size, shape and from different ethnic origins. Note the disparities in the width of the central band, the angle and curve of the nostrils, the shape of the highlights and shadows.

EXERCISE

Draw as many different nose shapes as you can. Look in newspapers and magazines for reference material, or simply sketch while you are watching the television.

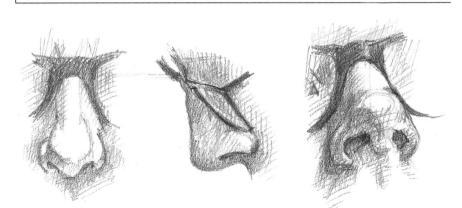

THREE VIEWS OF THE SAME NOSE *Graphite pencil*

These spectacles help to define the bridge of the nose.

MOUTHS

The mouth is the most mobile feature and consequently very expressive. The slightest change in the corners of the mouth will change the expression – this is quite useful to know if you want to give your subject a hint of a smile. The largest differences between mouths are those of age, gender and ancestry. Lips in particular vary greatly in size and thickness depending on the model's expression, ethnicity and facial structure.

The underlying structure of the teeth and the fullness of the lips give the mouth its shape. The lower lip is frequently fuller than the upper lip and may have no outline to delineate it, but instead be defined simply by highlight and shadow. Use the curving lines of the creases in the lips to emphasize shape and form. Observe the line defining the lips carefully as it should be drawn sensitively.

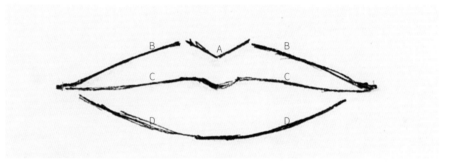

TIP

If you are working from life, chatting to your model will prevent a 'set' expression and animate all parts of the face, including the mouth.

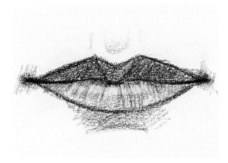

The upper lip is divided into three parts, with a central triangle that forms the 'Cupid's bow'. In normal lighting conditions, the upper lip is usually in shadow and therefore darker than the bottom lip.

From the front

To draw the mouth front-on, start in the middle with the 'Cupid's bow' (A), which may be quite acute or flattened. Next, sketch in the curve of the upper lip (B), then the mid-line (C), which may dip beneath the 'Cupid's bow'. Lastly add the lower lip (D) which is sometimes defined only by a patch of shadow beneath it (see below right). The corners of the mouth are usually the darkest part, where the muscles push and pull the mouth into the cheek.

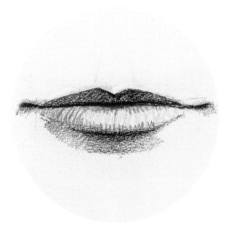

A fairly thin upper lip and flattish lower lip, defined by the straight lines running across it. The slight upturn of the corners give this a pleasant expression.

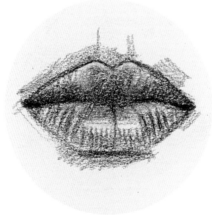

Here, both lips are full and rounded, with the curve of the lower lip emphasized by the rounded creases.

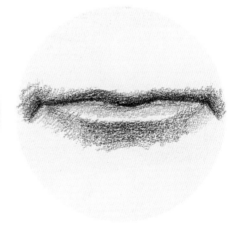

This mouth of an older person shows a thin upper lip, with the lower lip defined only by the shadow beneath it. The corners are turned down, giving a rather dejected expression.

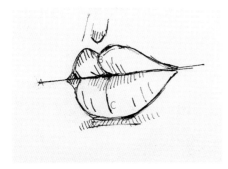

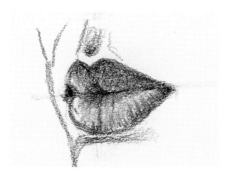

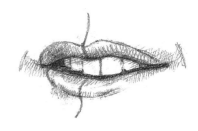

From the side

This three-quarter view mouth is in perspective, which means the left-hand side is narrower than the right-hand side. The diagram shows the stages for drawing it, beginning with a line to establish the angle of the mouth (A). In such a view from the side, putting in a centre line helps to align the lips. This is marked (B) for the upper lip and (C) for the lower lip.

Using the central axis will help align the lips, even if they are parted. Note that the teeth are set back, so the centre line of the lips does not align directly with that of the teeth.

Teeth and smiles

'Smile please' is the usual request before taking a photograph, so if you are working from photographs, you will often have a smiling face, revealing a mouthful of teeth. These can be a big challenge to draw.

Ideally, take your own photographs and ask your sitter to smile and then relax; this will result in a hint of a smile lingering on the lips, without presenting the problematic 'gnashers'! With that said, such 'snapshot' compositions are often memorable, and worth the effort.

As a general rule, do not draw each individual tooth; instead establish the centre line, draw the shape of the gum line, then the base of the top row of teeth. If you can see the lower teeth, draw these too.

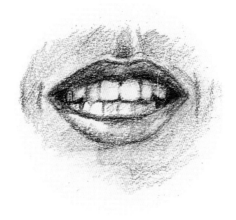

Visualize the teeth as a curved band. As the band recedes into the mouth, it is in shadow. The corners of the mouth and the space between the upper and lower teeth can be quite dark.

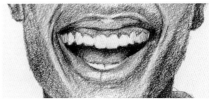

Snapshots often give the most natural results. In this example you can also see the tongue. Note that only a few of the lower teeth are visible. In this example, I drew the centre line, the line of the gums and the shape of the teeth, rather than drawing each tooth individually.

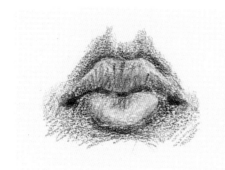

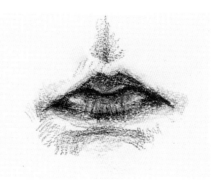

Baby mouths

The width of a baby's mouth is narrower in proportion than an adults. The lips are quite full – and often wet!

EARS

The ears are a feature that can often be overlooked, perceived as both insignificant and difficult to draw; but they are just as important as the other features and should be drawn with equal observation and care.

Although they vary a great deal in shape, they have the same characteristics in each person and are the same for male and female. The ears can grow and lengthen with age. This is particularly apparent in older men.

Structure of the ear

It is not necessary to learn the names of the parts of the ear but they are useful to know for identification purposes.

The helix is the outer rim of the ear, which sweeps round ending in the concha, the central concave part. The anti-helix forms an arc between the helix and the concha, meeting the tragus which can vary a lot in size and shape.

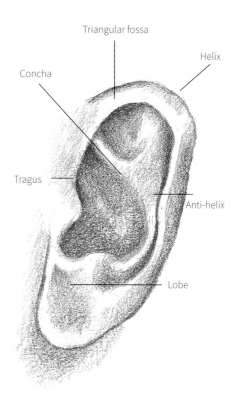

Triangular fossa

Helix

Concha

Tragus

Anti-helix

Lobe

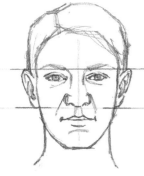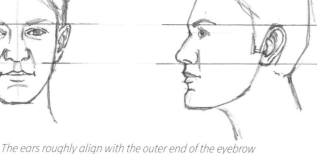

The ears roughly align with the outer end of the eyebrow and the base of the nose.

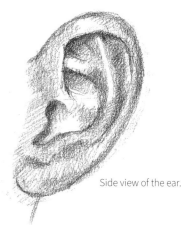

Side view of the ear.

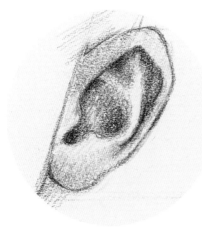

The top of this ear comes to a point and the anti-helix is quite prominent, catching the light.

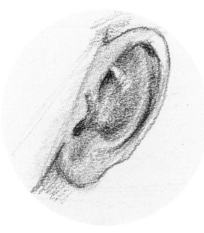

Here, the triangular fossa and the concha are relatively shallow and the tragus rather small.

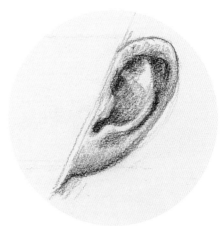

In this example, the lobe is attached to the side of the jawline, a characteristic that can be inherited.

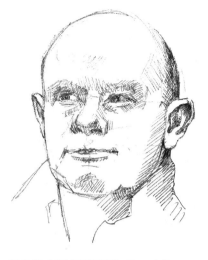 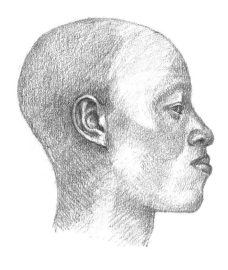

EAR VARIETY *Graphite pencil*

*The ears can lie flat or, as on the left, protrude, which can add to the character of the subject.
It is important to place the ear correctly, particularly in a profile or three-quarter pose (centre).
It is a common fault to minimize the distance between the ear and the corner of the eye which
reduces the fullness of the skull and in turn changes the likeness. The little girl's ears (right)
seem to be a rather insignificant feature, but in fact they set the position of the jawline and side
of the head, giving shape and definition in this area.*

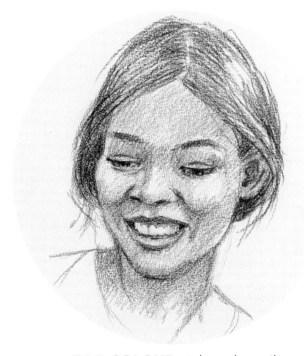 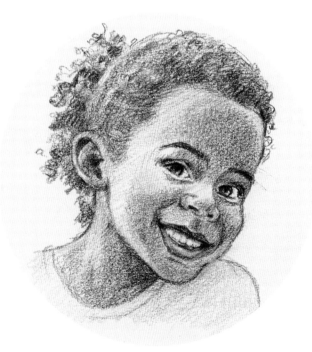

EAR COLOUR *Coloured pencil*

*As the blood comes closer to the surface of the skin in the ear, they are
usually pinker than the other skin tones.*

ACCURACY OF ANGLE *Coloured pencil*

This little girl's ears slant back and also jut out a little.

PROORTIONS

We can look at someone and decide they have a long face, wide cheekbones, big eyes, a long chin or a broad nose. Faces vary hugely depending on individual differences and ethnic origins. Nevertheless there are general guidelines in facial proportions that can help the portrait artist to place the features correctly. Note that the features occupy a relatively small area of the whole head.

Age, gender, ethnicity and natural variation all add to the differences in people's appearance. The drawings shown on these pages illustrate faces from around the world, demonstrating the variations in proportions.

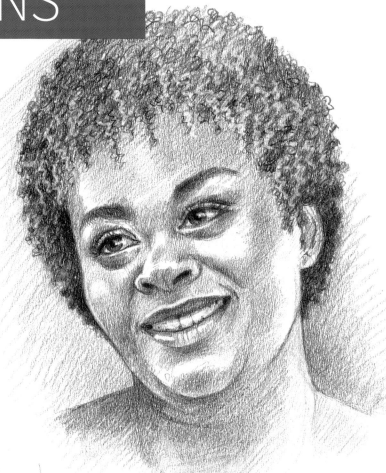

ELSA *Graphite pencil*

This lady has a short, wide nose, high cheekbones and a wide mouth. Her African ancestry is apparent in her features and her tight curly hair.

INDIAN WOMAN *Graphite pencil*

This young woman looks quite determined with her long, broad nose and heavy eyebrows. Her headdress and veil frame her face, contrasting with her skin tone which I have suggested with hatching and cross hatching pencil marks.

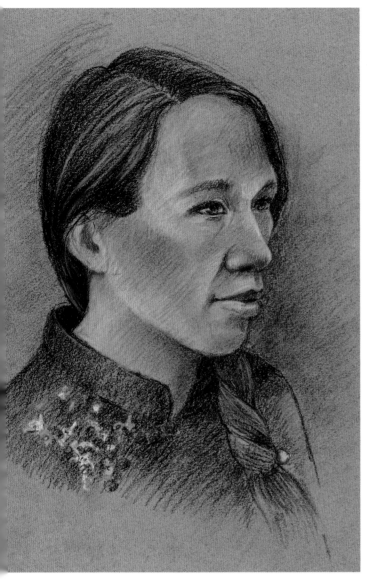

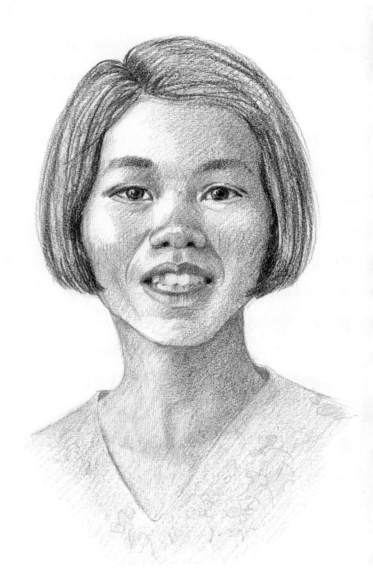

ROS *Pastel pencil*

This sketch was done from life. Ros has European proportions and skin tones with dark hair. Her nose is shapely – quite a challenge to get it right – and she has full lips.

HUE *Coloured pencil*

Hue's almond-shaped eyes tilt downwards from the corner to the tear duct. The bridge of her nose is shallow while she has high, wide cheekbones giving the head a flatter, broader appearance.

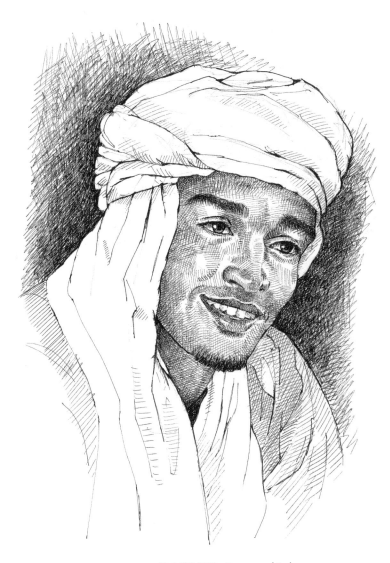

BASHIR *Pen and ink*

I met Bashir in a market in Marrakesh; as he recounted fascinating tales of his nomadic life as a Toureg in the desert, I looked at his handsome face and fine features – high cheekbones, a well-defined nose and flashing brown eyes. He let me take photographs, which I used for this pen drawing that I hope captures his character.

LUKE *Pastel pencil*

Luke has been a model on many of my portrait courses and he always has a smile lurking on his lips, as you can see from my portrait. He has a high coloured complexion which I have tempered by using blue-grey pastel paper and pastel pencils.

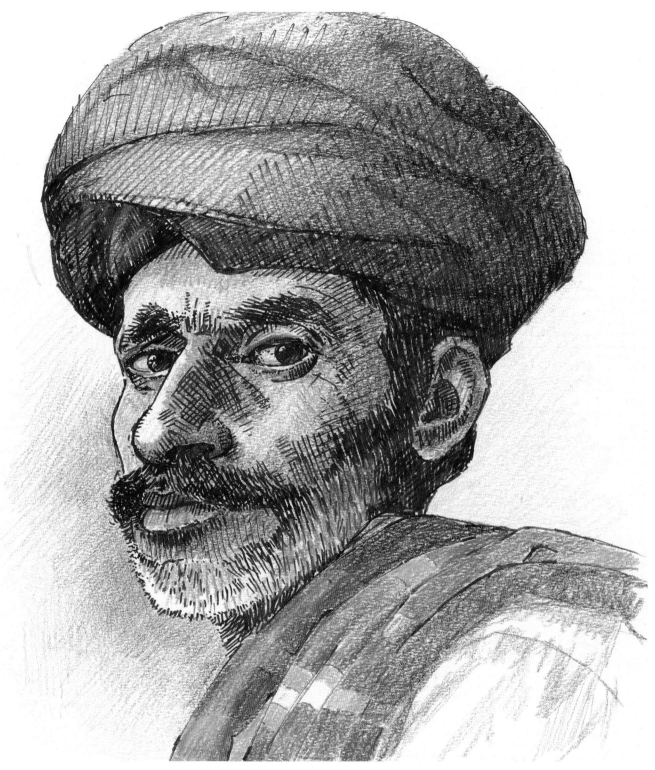

TARUN IN TURBAN *Mixed media*

Tarun has a long, narrow face with high, pronounced cheekbones, deep-set eyes and a heavy brow. His glaring look is challenging to capture, but makes a good study. I added coloured pencil to my ink drawing.

UNIVERSAL PROPORTIONS OF THE ADULT HEAD

There is enormous variety in how people look, regardless of their ancestry, gender or age, so you cannot usefully group faces into any one 'norm' – doing so is more likely to lead you astray than help with accuracy. As ever, then, it is vital to assess the person as an individual or look at the photograph in front of you and use these diagrams and notes only as general guidelines.

- In a straight-on view, the eyeline is midway between the top of the skull and the base of the chin.

- The width between the eyes equals the width of the eye; tear duct to corner.

- The width of the eye is equal to the distance from the outer corner of the eye to the side of the head.

- The width of the nose is usually the same as the distance between the eyes.

- The mouth is usually no wider than the distance between the pupils.

- The ears align with the outer corner of the eyebrow and the base of the nose.

- The female head is smaller than the male head, but the proportions remain the same.

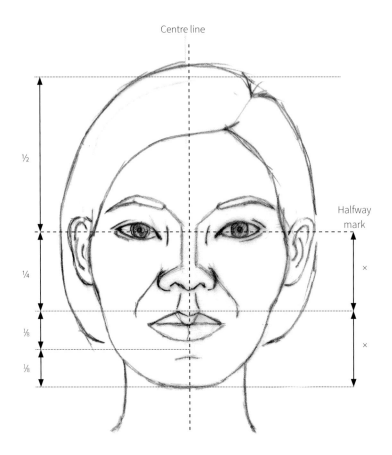

An example of facial proportions, demontrating the general rules listed above. The centre line and halfway mark are picked out in dashed lines. These are the axes that help to find the position of the face on the head, whatever the angle you are drawing.

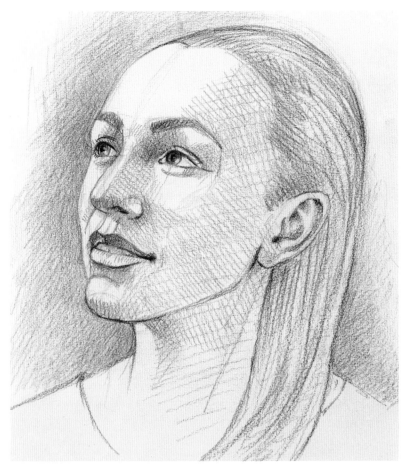

JESSICA *Coloured pencil*

Determining the axes of the head – the centre lines vertically and horizontally as shown on the diagram opposite – is a very useful aid in aligning the head, enabling us to judge the rotation and angle of the head. As Jessica looks up, we see less of the top of the head, and her eyeline is above halfway.

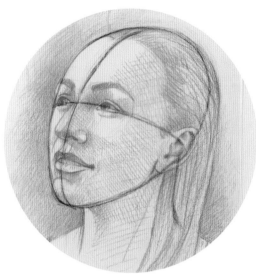

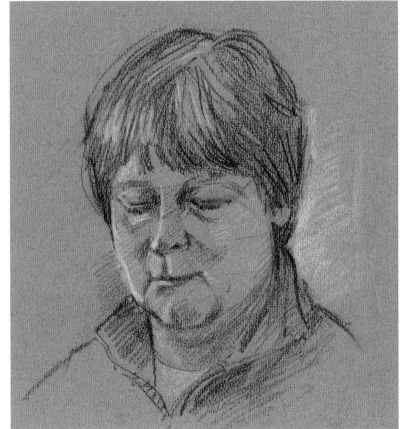

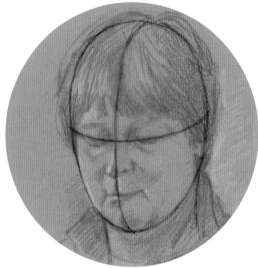

BRIDGET KNITTING *Pastel pencil*

Bridget looks down at her knitting, so we see more of the cranium and hair, due to the horizontal axis being below the halfway mark. Her head is rotated to the left, but comparing the position of the axes in these drawings, we can see more of the left-hand side of Bridget's head than in the drawing of Jessica.

AFRICAN PROPORTIONS

The general proportions of the head are broadly the same for all adult humans; though slight ethnic variations can sometimes be a pointer as to their origins. Compare the spacing of the eyes here with the Asian and European proportions on the following pages – you will see they are almost the same. This is an area that is relatively similar regardless of one's ethnicity.

There are some general differences to look for that can help you with your portraiture: people of African origin tend to have wider and shorter noses, and fuller lips. African people's ears tend to be quite small in comparison with Europeans and Asians. These are, however, generalities – so always look to the individual sitter for specifics; their idiosyncrasies will always be a better guide to a likeness than looking for predetermined rules.

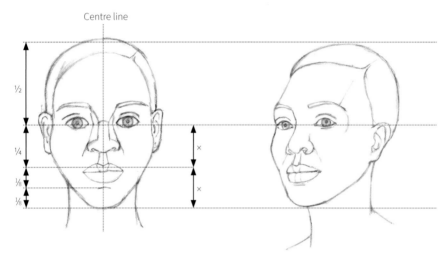

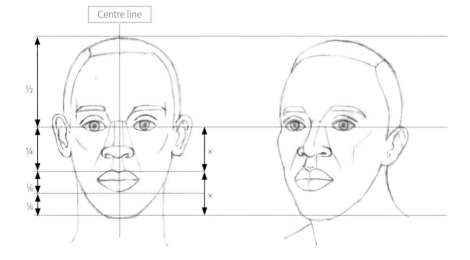

The facial proportions of two African adults in full face and three-quarter views.

The woman's head shows that the spacing of the eyes is quite wide, her nose broad and short and her lips full and she has high cheekbones. The man's head is turned slightly to the right, showing a deep brow ridge, high cheekbones and a strong jawline. His neck is noticeably wider than the woman's, a feature typical of most men, regardless of their ethnic origin.

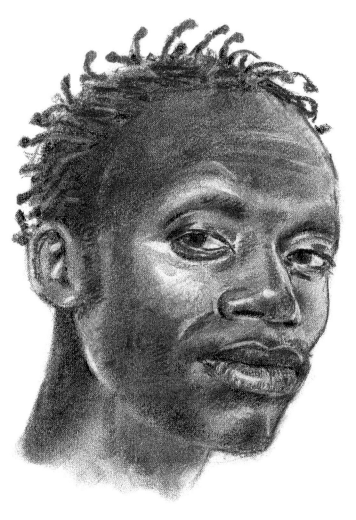

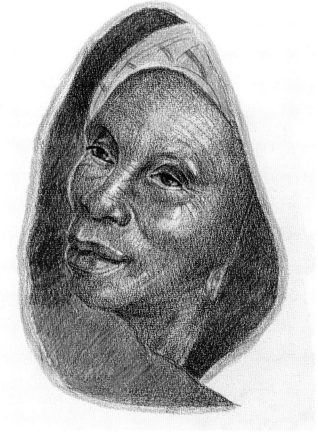

Above:

BYRON *Charcoal*

As well as a wonderful dark skin with lots of interesting highlights, this man has a strong brow with large eyelids, a wide, flat nose and very full lips. His ear, by comparison, is relatively small, and the hair very striking!

Above right:

GAMBIAN ELDER *Coloured pencil*

This angled three-quarter view of this fascinating and beautiful face makes an interesting composition. She has high, pronounced cheekbones, deep-set eyes and a prominent jawline that pushes her lips forward. The curving outline of her face stands out against her red shawl.

Right:

TYRONE *Graphite pencil*

This man has a long slim face with shallow cheekbones. He has a wide nose, more aquiline than the man above.

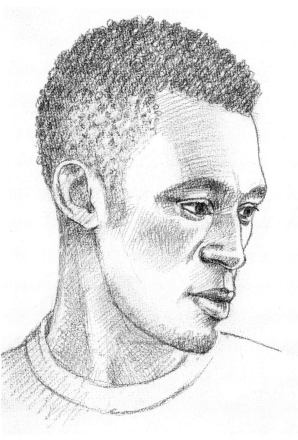

ASIAN PROPORTIONS

As noted earlier, trying to generalize ethnic facial features is reductive, so I have given you models of an eastern woman's proportions and those of an Indian man to show just some of the variety in facial shapes of people from Asia.

A typical characteristic of Far Eastern people is that we do not see a separate crease in the fold of the eyelid; more often, the eyelid has a hooded effect – compare the Far Eastern woman with the Indian man below to see the effect this has.

Asian people usually have black or dark hair colouring, but one cannot generalize on the colour of skin as the variations are so great – on every continent. Asian skin tone varies from quite pale, as in the Japanese businessman (see opposite, top), to darker tones, as in the portrait of Rashmi (see opposite, bottom).

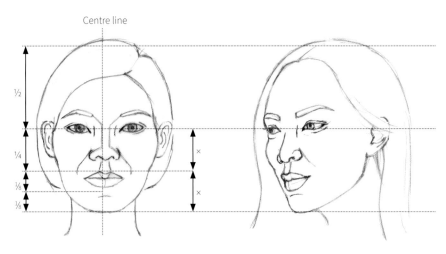

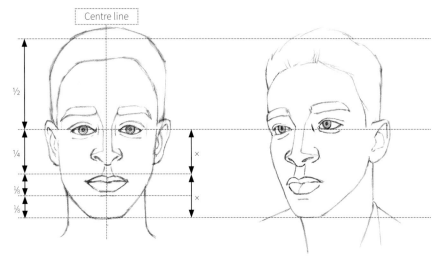

The facial proportions of a Far Eastern adult woman (top row, left), and an adult man from the Indian subcontinent (below, right), in full face and three-quarter views. The woman's eyes slope down from corner to tear duct, giving an 'almond eyes' effect. Her cheekbones are high and rounded; and form the widest part of the head. The bridge of her nose is relatively flat; a line drawn from the tear duct to the nostril will show that the nose is relatively wide, but is also quite flat.

The distance between the man's eyes is an eye-width, as with the African and European examples on previous and following pages. His eyes also slope down slightly, tear duct to corner, but this is not necessarily characteristic for everyone of Eastern origin – always look to the individiual in front of you.

He has a strong brow ridge with thick, dark eyebrows. The nose is quite broad but thinner than the African man's nose on page 52. It has a flat band running the length that catches the light, ending in a sharp highlight at the tip.

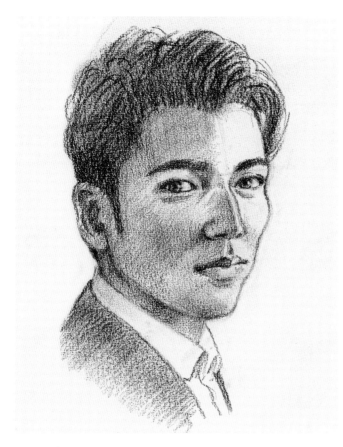

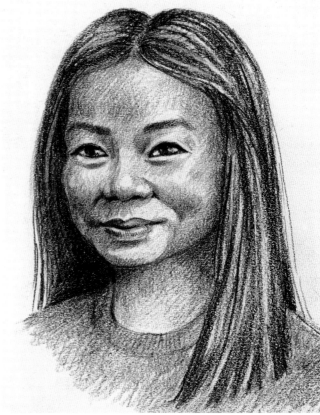

Above left:

JAPANESE BUSINESSMAN *Charcoal*

Here we see the distinctive high cheekbones and dark hair colouring that is indicative of a man from the Far East.

Above right:

LAN ANH *Coloured pencil*

Lan Anh, from Vietnam, has wide, almond eyes and high cheekbones. Her nose is quite flat and wide. Her skin tone is warm, but not dark. I used cream, yellow ochre and pale terracotta, adding purple in the shadows. Her hair reflects the light and colour of her clothing so, along with black, I added blues and a touch of red.

Right:

RASHMI *Soft pastel*

This Indian lady had bronze-coloured skin which I painted in warm tones – ochres, peaches and yellows. Her hair was very dark. Black can be quite harsh on its own, so adding a variety of browns and earth colours will help to make it look more natural.

EUROPEAN PROPORTIONS

The most noticeable differences between typical European proportions and those of Asian or African peoples is the longer, more slender nose; less prominent cheekbones; flatter nostrils, and thinner lips. Hair colouring varies a great deal from blond, to auburn and ginger through to brown and black.

It is useful to draw the centre line which helps to position the mouth beneath the nose as it can easily slip to one side, especially in a three-quarter view.

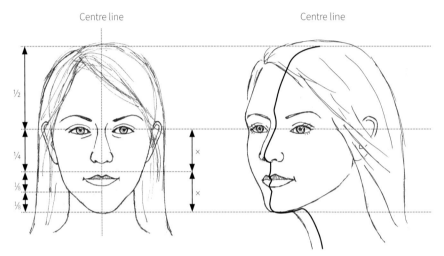

The facial proportions of an adult European woman and a man in full face and three-quarter views.

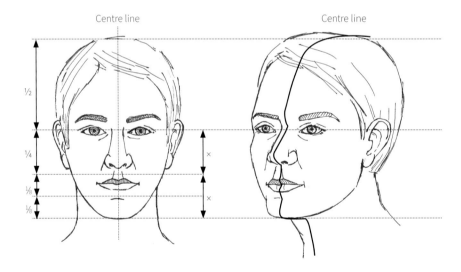

Top left:
JANE *Graphite pencil*

This is a full-face view, rotated slightly to the right (her left) – we can see slightly less of the ear on that side. The proportions and alignment more or less conform to the diagrams opposite. Note that the line of her clothing is only just below her ears. It's a common mistake to make the clothing too low, altering the proportions of the neck and shoulders and losing the likeness.

Top right:
RICHARD *Soft pastel*

The thickness of the hair has to be discounted when measuring the depth of the head to find the halfway line; you have to imagine where the top of the skull would be, but it is only a guide.

Right:
BRIAN *Graphite pencil*

This study, in 4B graphite pencil, shows the sitter straight on. Although tilted at an angle, his face is quite round and full. The cheekbones are not apparent but highlights nevertheless indicate the change of plane from the front to the side of the head.

PROPORTIONS AND AGE

Looking at these portraits, you know instantly that one is a teenage boy and one an old lady; you could probably guess within a few years how old they are. The differences in facial proportions of different age groups are so subtle; the tiniest change in position and size of the eyes, width of the mouth, how you apply shadow and add lines can make the difference between a five-year-old and a twenty-year-old.

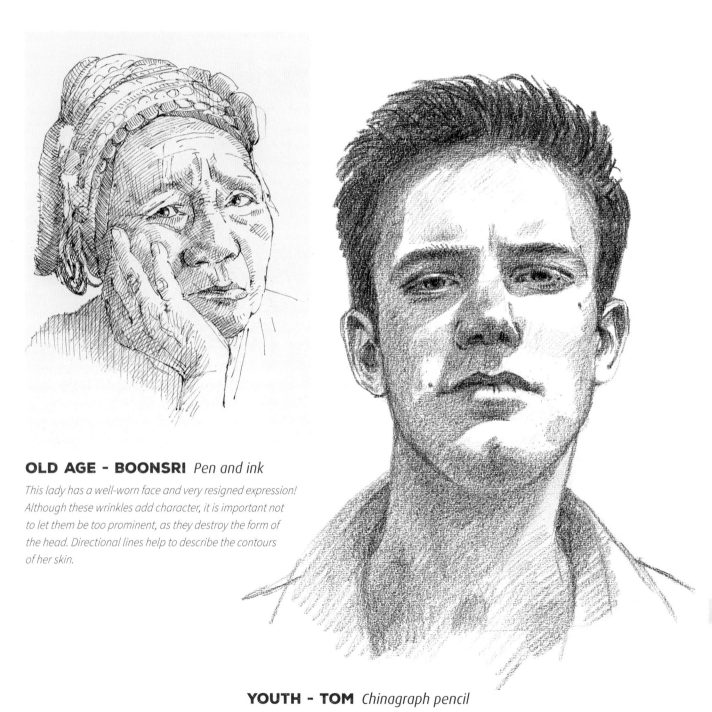

OLD AGE - BOONSRI *Pen and ink*

This lady has a well-worn face and very resigned expression! Although these wrinkles add character, it is important not to let them be too prominent, as they destroy the form of the head. Directional lines help to describe the contours of her skin.

YOUTH - TOM *Chinagraph pencil*

The facial proportions of this teenager are not yet quite those of an adult, and the pose is one with 'attitude'. Note how the shadows falling across his cheek and chin act as contour lines, describing the shape of those surfaces.

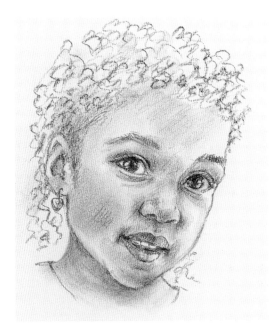

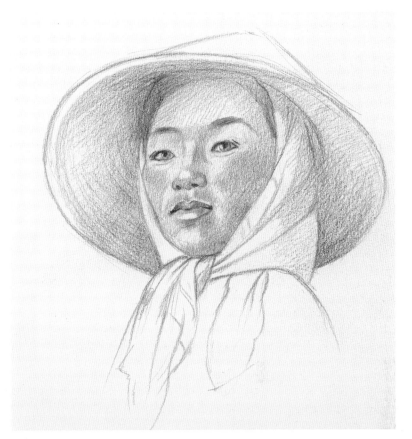

Above:

CHILDHOOD - MARISOL
Brown charcoal pencil

This young girl, probably about four years old, has large eyes, a small but full mouth and small nose. Her facial proportions conform to those of other young children worldwide.

Above right:

ADOLESCENCE - CHEN IN HAT *Coloured pencil*

This young girl is probably about sixteen but could be older – it is hard to guess some people's ages. Her proportions are those of an adult but her look makes her appear younger.

Right:

MATURITY - AMANDA
Pastel pencil

A well-defined face with clear-cut features. I used two brown pastel pencils plus white for this short monochrome study of Amanda, adding pale blue pastel pencils in the background to accentuate her features.

EXERCISE

Study the variations between these portraits. Draw your own versions, and see if you can change the perceived ages by altering the proportions. For example, make the little girl look older, the youth older (or younger) and make the old lady younger – I am sure she would love it!

Proportions of a child's head

It is important to get the subtly changing proportions of a child right according to his or her age. If you have ever tried to draw a baby or young child and the result looks like a much older version, this is likely because the proportions of the features within the head shape are incorrect. This page is designed to help you understand where you went wrong!

In comparison to an adult's head, the following general rules apply:

- The eyeline is below the halfway point, the cranium being much bigger.

- The eyes are wider apart and the iris appears large within the eyelids.

- The nose, mouth, jaw bones and teeth are much smaller.

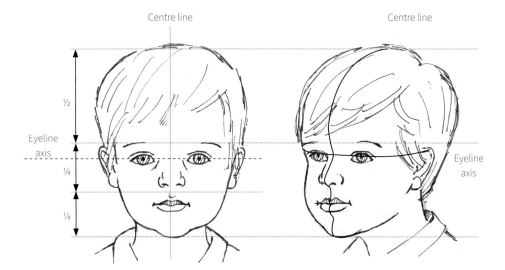

The facial proportions of a child in full face and three-quarter views. The head is approximately half the size of an adult's head. The diagram shows the proportions of a four-year-old child. Younger children's and babies' proportions would show a lower eye line, which gradually moves upwards as the child grows. Around sixteen years of age, adult proportions are reached and the eyeline will be around the half-way mark between the chin and the top of the head.

Portraits of children

In addition to differences in proportion, the following are guidelines for achieving good results when drawing portraits of children:

- There are no hard lines.

- The eyebrows are sometimes insignificant.

- The hair is very fine.

- The neck and shoulders are quite thin and narrow.

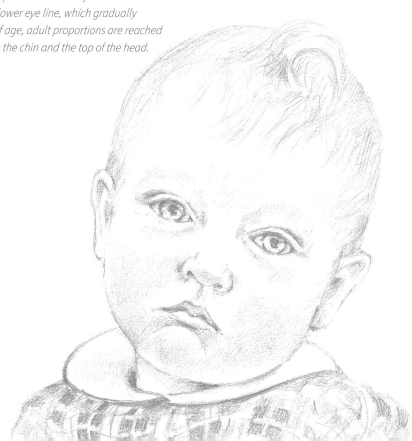

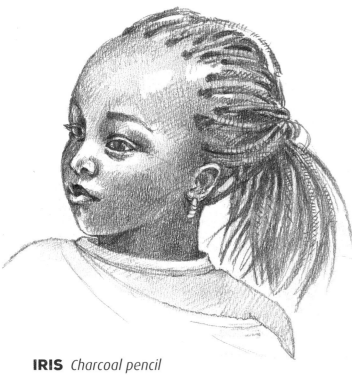

IRIS *Charcoal pencil*

This three-quarter view, looking down on the subject, shows us how large the cranium is in proportion with her features. This is emphasized by her hairstyle.

ERNESTO *Soft pastel*

This young boy looks shyly up to the camera – expression and body language help to suggest his youth. His skin tone is quite dark and, from this viewpoint, his large brown eyes appear asymmetrical.

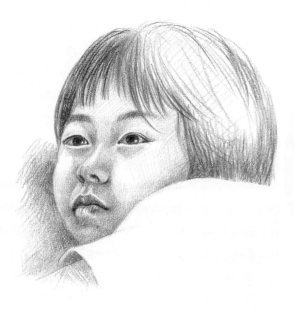

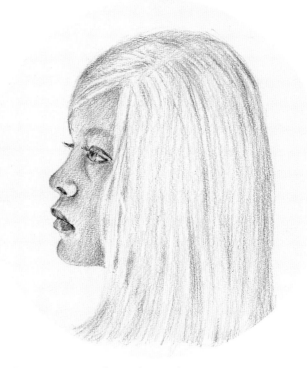

LI *Coloured pencil*

This little Chinese girl is probably about four years old. Unlike Ernesto, above, her expression is confident; her gaze direct – which just goes to show that observing individual character is more important than sticking to rigid rules.

CLAUDIA *Coloured pencil*

Facial proportions are still developing in this twelve-year-old girl; the position of the eyeline is just below half-way but the cranium not as large as in the younger children featured on this page.

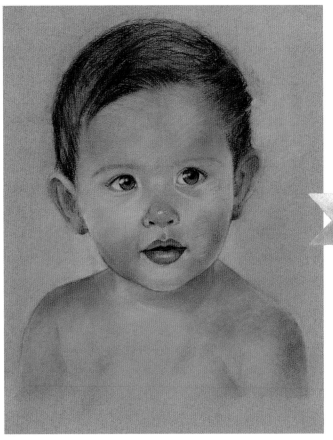

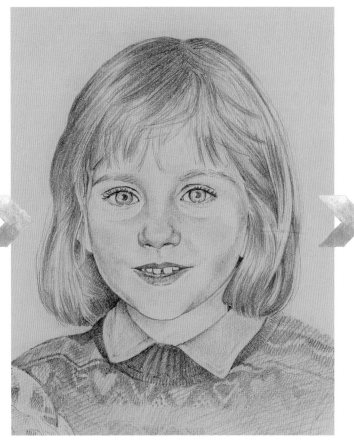

POPPY, 15 MONTHS *Soft pastel*

In this portrait of a toddler, we can see that the eyeline is below the halfway point of the head; the cranium is quite large and she has big, wide-apart eyes, a small nose and mouth, and a small neck.

ALICE, 8 YEARS *Graphite pencil*

Alice has the wide-eyed look and small mouth of a young child, yet her features are starting to develop.

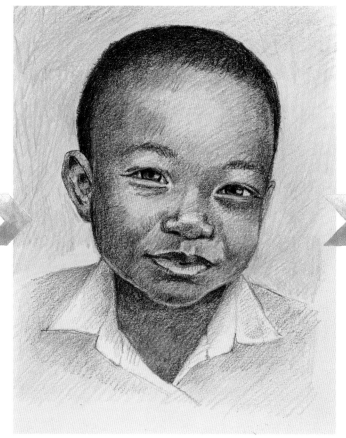

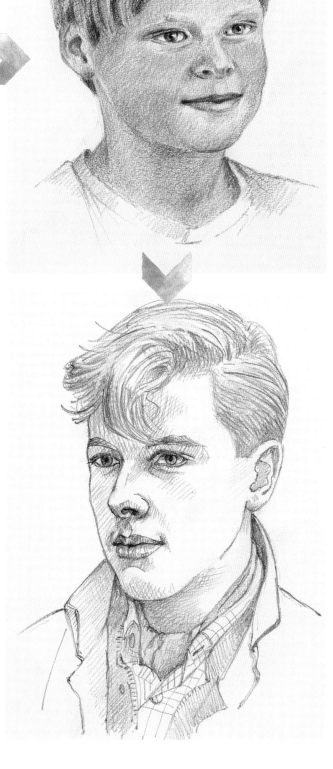

Top left:

SOPHEAK, 9 YEARS *Pastel pencil*

This young Asian boy has the wide-apart eyes and large forehead of a child, yet his nose and mouth are larger and wider than the toddler's.

Top right:

FERGUS, 11 YEARS *Coloured pencil*

Here the proportions of the features and head are no longer those of a little child, but not yet adult proportions.

Right:

EDWARD, 16 *Graphite pencil*

Although this lad has the proportions of an adult, his skin texture, lack of lines and fresh complexion are telling of his age.

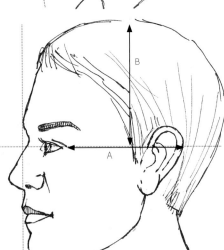

PROFILE PORTRAITS AND PROPORTIONS

It can be quite tricky drawing a profile as one cannot use the eyes–nose triangle method (see page 68) that can be used for three-quarter or front views. However, using a pencil to measure vertically, horizontally, or at an angle will help to plot the features accurately and establish the relative position of one feature to another.

The examples on theses pages show some different approaches and examples for drawing heads side-on. To the left, you can see that the child's forehead is large and rounded and therefore forward of the lips and chin. The forehead slopes back at an angle. In the adult examples, the vertical line shows that the bridge of the nose is in line with the recession beneath the lips. This makes it easier to assess the angle of the nose and also how much the lips and chin protrude. Compare the examples to the left with Lale, below, and the examples opposite.

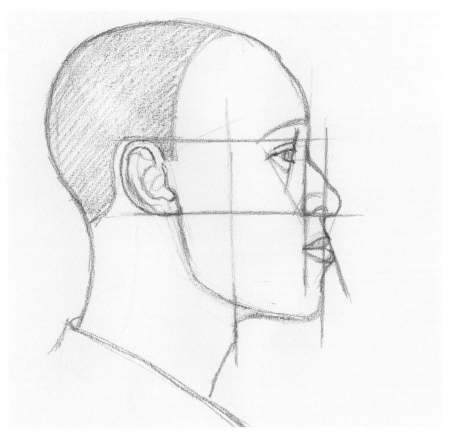

LALE *Charcoal pencil*

The measuring lines have been drawn in contrasting blue pencil for clarity. Having drawn the eye and eyebrow, I held out the pencil vertically and drew a vertical line. I noted that the bridge of the nose, edge of the nostril and corner of the mouth were all more or less aligned with this. Next, I measured and drew the angle of the nose. Another vertical measurement confirmed that the upper lip (philtrum) and the area below the lower lip are aligned. The bottom lip of this sitter protruded beyond the upper lip – another angled line established by how much. In this way, the profile is built up, step by step, line by line, angle by angle.

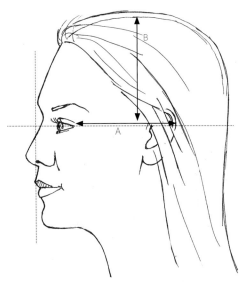

In profile, the distance between the back of the eye and the back of the ear is equal to the distance between the eyeline and the top of the skull. When using this rule of thumb, take the height of the hair into account.

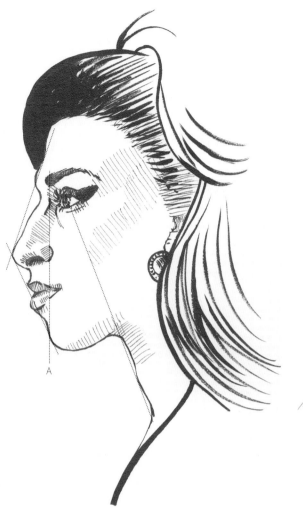

AMY *Pentel brush pen*

I sketched in the eye and eyebrow, then drew a vertical line (A) from the bridge of the nose to the chin. This allowed me to assess how far the nose and lips protrude; with successive angled construction lines plotting out the length, width and angles of the nose and mouth. These initial straight lines can be refined, rounded and softened to reflect the subtle concave and convex curves of this distinctive profile. A line from the eye through the chin helped with finding the angle of the neck.

ROS *Ballpoint pen*

I sometimes prefer the ease of using a biro for a quick study, as here with the profile view of Ros. Many fine lines can be built up easily and, if used lightly, mistakes hidden with heavier, corrective marks. If they cannot be corrected, then white-out fluid can help to obliterate them, as I have done here round the nose and neck.

TIP

Sometimes I like to leave in the construction lines to show the progress of a drawing or painting, giving it a life and character of its own.

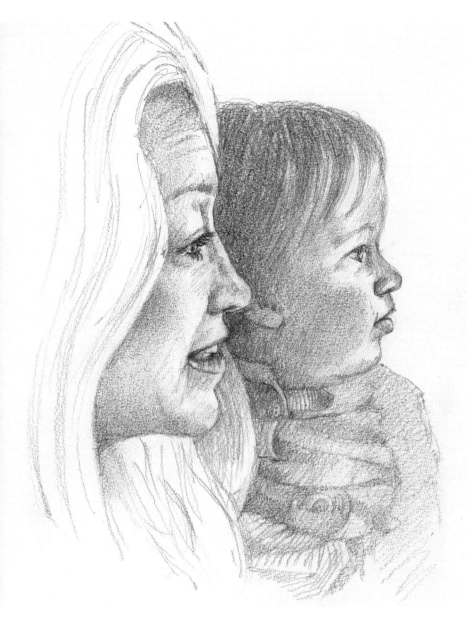

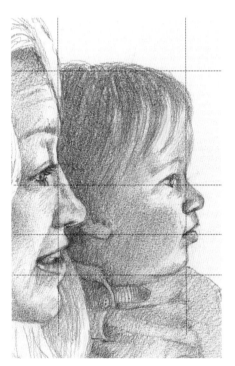

SEE THE BIRDS *Graphite pencil*

I love this subject of auntie and niece, both looking intently out of the window. I started with the adult's eyes, then worked with vertical, horizontal and angled lines to capture an accurate rendering of her profile. Moving on to the toddler's head, I plotted horizontal lines across to assess first the total depth of her head compared with the adult's (see right), then the relative position of her eyes, nose and mouth before refining these markers to build up her profile.

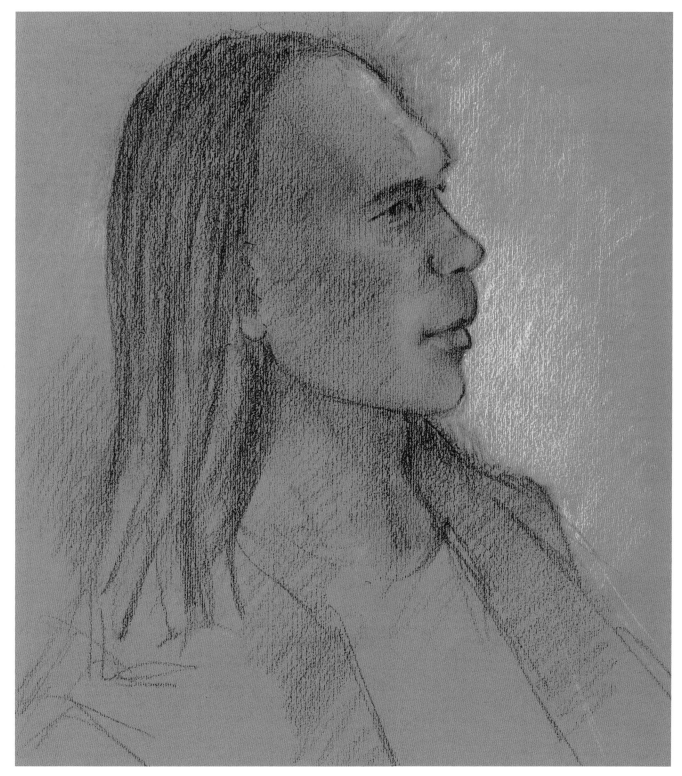

COLIN *I sketched Colin from life and although my construction lines aren't apparent,*
I nevertheless went through the same process of measuring and assessing angles to build up
the profile, sometimes marking with a dot instead of a line for each stage.

CAPTURING A LIKENESS

THE EYES–NOSE TRIANGLE

Any view other than full face distorts the features making it difficult to analyse what is true. Too often we draw what we think we see rather than what is actually in front of us. Once you have drawn the eye line and central axis and the eyes, you can use the eyes–nose triangle system of measuring explained here to help to establish the length and position of the base of the nose. It can also be used to fix the position of the centre of the mouth and is a method I use frequently working either from a model or from photographs.

When working from life, it is usual to work upright on an easel so that the image of the model is alongside your working surface. Having measured and drawn the angle of the eyeline and the eyes, hold the pencil in mid-air. Align it with the pupil of the eye and the base of the septum, then swing your arm across to mirror this angle on the paper. Repeat for the other side. Check the angles are correct by repeating the whole process.

If you are working from a photograph secured to your board, lay the pencil on the angle to be measured, then swing it across, being careful to replicate the angle. Repeat for the other side and double check your angles are correct. I prefer to draw these construction lines freehand rather than use a ruler, which I find too mechanical.

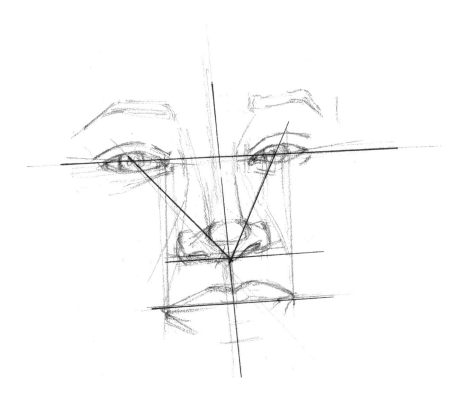

Construction lines and the eyes–nose triangle

This young girl's head is slightly tilted and turned to one side a little, so that we can see more of the left-hand side of her face (her right). To the left, you can see the construction lines of the eyeline, the central axis and the eyes–nose triangle.

Because she is leaning forward, the line of her shoulders comes up to her jawline. To draw her hair I scribbled in the mass, then carefully defined the corkscrew curls, particularly at the edges.

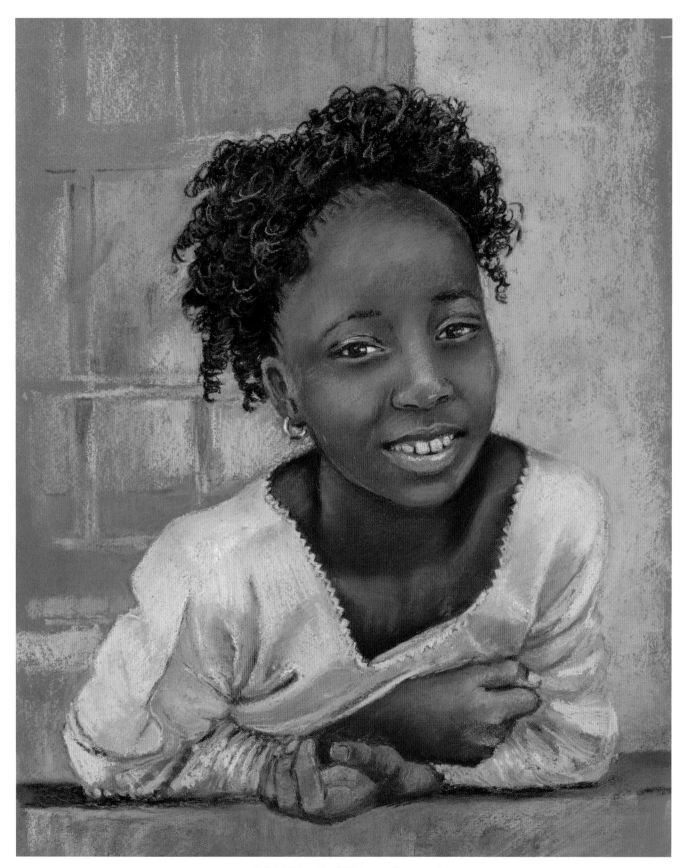

GAMBIAN GIRL *Soft pastel*

Using the eyes–nose triangle

This three-quarter pose, looking slightly down at the model, is another example where I found the eyes–nose triangle measuring system extremely helpful. It is very difficult to judge the length and position of the nose without this useful technique.

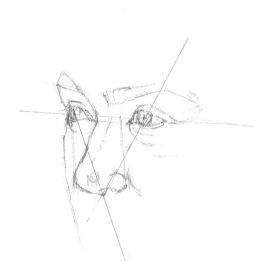

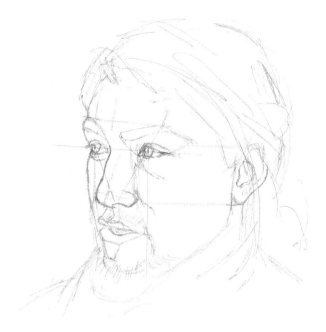

1 In pencil, draw the eyeline and mark the position of the pupils. These determine the size of the finished portrait. Sketch in each eye, observing the distance between the tear ducts, the differing shapes of each eye and the negative shape between the upper lids and the eyebrows. To assess the length of the nose, draw a diagonal line from the pupil of each eye to the base of the nose to form a triangle.

2 By drawing vertical lines from the eyes, I can plot the width of the mouth and then judge its distance from the nose by comparing that with a similar distance elsewhere on the head. Assess the position of the ear by measuring across to the nose and comparing that with a similar distance.

3 With the features accurately established, redraw them in ink, continually reassessing and altering where necessary. Begin lightly, using dotted and broken lines, then strengthen and emphasize the features.

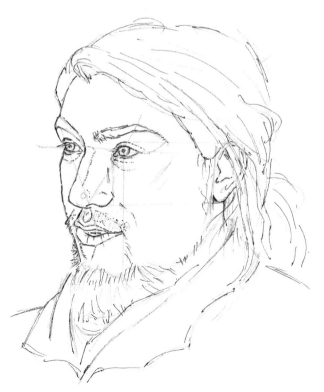

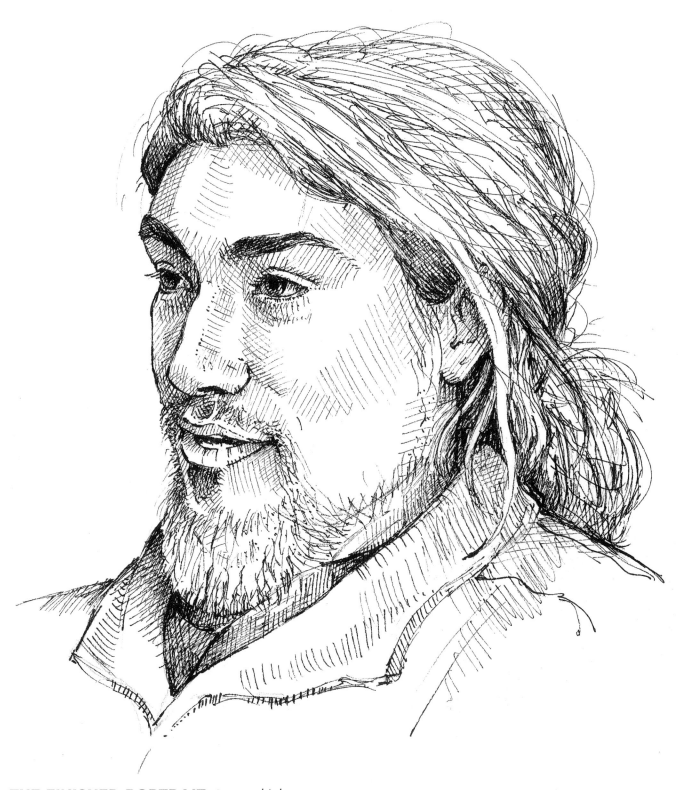

THE FINISHED PORTRAIT *Pen and ink*

*Shading is selectively added to complete the portrait. Less is more with pen and ink,
particularly with the beard and hair. Had I drawn them as dark as they appeared, they would
have overpowered the portrait. I emphasized a long, light strand of hair by darkening behind
it. Having completed the drawing, I erased some of the pencil lines, particularly those that
interrupted the flow of the portrait.*

DIMITHRA

The paper we use here has a rough and a smoother side. For this project I suggest you use the smooth side. Work upright, if possible, as this will help avoid distortion. With a photograph, you can decide how big you want to work. When working with pastel pencils, note they are a broader medium than graphite – this is, they don't come to as fine a point. If you have a typical 15 x 10cm (6 x 4in) photograph, I suggest you work roughly at one-and-a-half times larger to account for this.

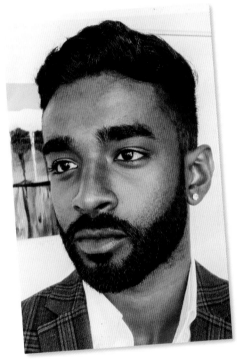

A photocopy of the source photograph for this drawing.

1 Use bulldog clips to secure two or three sheets of the paper to the board (this cushions the surface slightly. You can use any spare paper for this, even newspaper), and anchor the base with masking tape. Secure the photograph with the bulldog clip, too. It's important that it remains securely placed, in order to ensure the angles remain consistent.

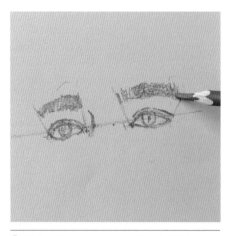

2 Using the maroon pencil, establish the eyeline. Place the pupils, and then build up the shapes of the eye. Note that because the subject is turned slightly, one eye appears smaller than the other. Although the subject's eyes are dark, we use a midtone (Maroon P170) because this enables us to correct our work – we can lay black over the top of maroon, but not the other way around. Draw angled lines up from the corners of the eyes to help place the eyebrows, using hatching marks to build them up.

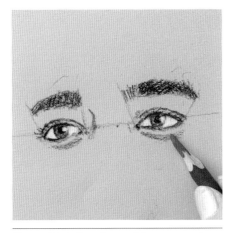

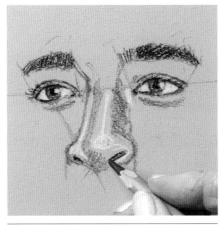

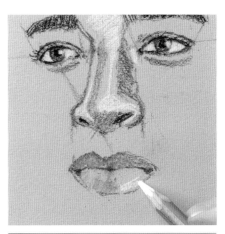

3 Establish the whites of the eyes, and some fine highlights, with white pastel pencil. We place these now in order to help keep the colour clean. Next we add the darkest tones to the eyes and eyebrows with black, switching to dark brown (Chocolate P590) for the irises. Work carefully, to leave the highlight in place. To complete the eye region for the moment, use the maroon pencil to add some shading around the eyes.

4 Still using maroon, draw in the nose. To work out the length, measure the angle from each pupil in turn to the base of the nose. To gauge the width, hold the pencil vertically at the side of the nose and see where it intersects the eye. Draw the nose using the maroon pencil, oulining the shape of the tip with white and swapping to black for the nostrils. Keep an eye out for fine highlights near the eye. Build up the tone with these three colours.

5 Use the triangular measuring system from the pupils (as for the nose) to find the centre of the mouth. From this viewpoint, it will be slightly to the right of the base of the nose. Plot the width of the mouth with vertical lines, then build up the shape. There is no hard outline to the lips, and the line separating the top and bottom lip is slightly wavy. Use the dark brown pastel pencil to draw it in sensitively. Change to violet to shade in the top lip, and pale pink for the bottom lip. Blend in violet to the bottom of the lower lip, and add a subtle white highlight.

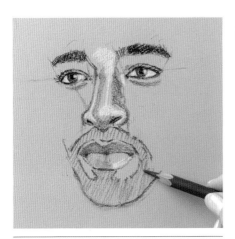

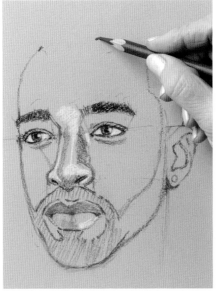

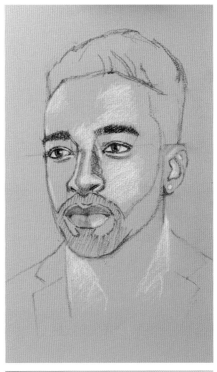

6 Measure the distance from the bottom of the lower lip to the chin, using the eye as your base unit of comparison. With the bottom of the jaw placed, suggest the outline of the beard with broken, sketchy marks of dark brown. Lightly hatch the area in.

7 Switch back to maroon to place the visible ear, aligning the ear lobe with the base of the nose. Mark in the outline of the head, then make two or three measurements to gauge the hairline accurately.

8 Use dark brown to add the mass of hair, then switch to white for the shirt. Suggest the neck and shoulders with dark brown.

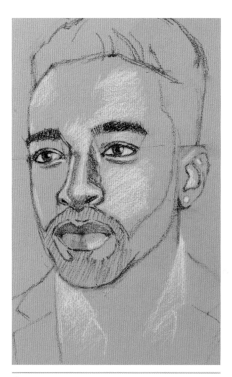

9 Build up the highlights across the whole portrait with white. The tone of the paper itself wll create the light midtones.

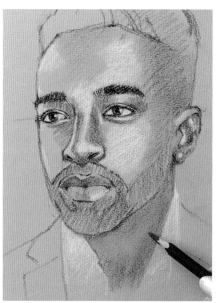

10 Use light maroon for the paler shadow, smudging it into the surface with a clean finger. Work right over the hairline at the side of the head – here the hair is cropped so close that the skin can be seen – and work with particular care over the ears and eyes. Check your source photograph often.

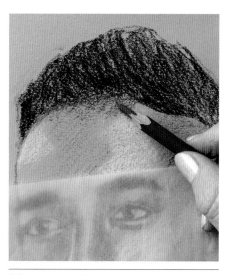

11 Switch to black to build up the darker tones, varying the hue with some maroon. Follow the movement and shape of the hair in order to avoid it becoming an unconvincing solid block of colour, and avoid a stark hairline by blending the edge with maroon. As you work, use a piece of scrap paper (I'm using tracing paper) underneath your hand to avoid smudging the work you've already done.

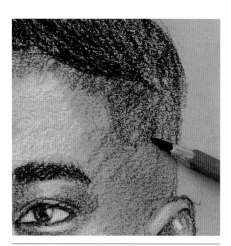

12 Using the pencil on the side of the tip will give a softer, subtle effect, as it will just catch the raised surfaces of the paper texture.

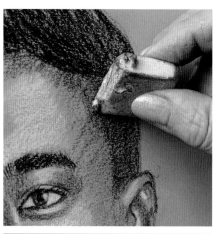

13 To lighten any areas that you feel are too stark or dark, you can dab and lift with a putty eraser.

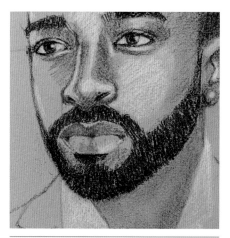

14 When developing the facial hair (using black), use marks that suggest the direction of growth. The left-hand side appears darker and thicker, while on the right-hand side some more of the underlying skin can be seen through the hair, so use less dense marks on the right. Intersperse some maroon marks alongside the black to avoid it becoming too stark.

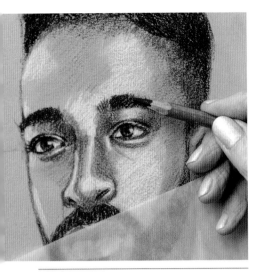

15 With the drawing complete, the tones need rebalancing. The early marks, having been placed in isolation, can sometimes look too subtle in the context of the broader portrait, so we need to work over them to strengthen them. I have used black to reinstate the dark of the eyes and eyebrows, and maroon both to reinforce the tear ducts, and to suggest the shadow cast by the eyelid on the eye itself.

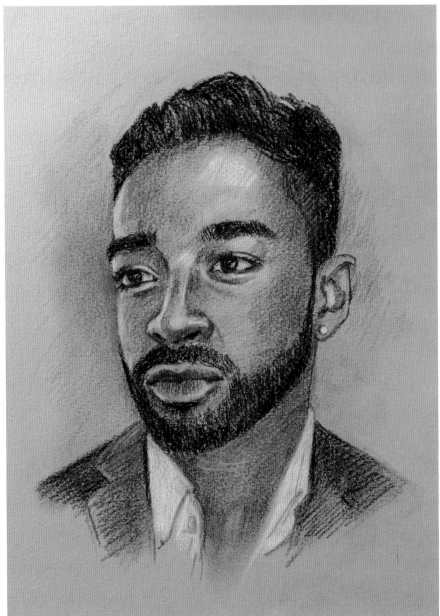

THE FINAL DRAWING *Pastel pencil*

The last stage is to add colour and detail to the clothing, which needs to be convincing without being overcomplicated. I decided that blue would contrast better with the skin tones (rather than the colour in the photograph), and also used black to add depth. I lightly drew in the shape of the collar and button, then I switched to the white pastel pencil to intensify the colour of the white shirt.

As I had introduced a new colour for the clothing, I wanted to use it elsewhere; sometimes I use the added colour to add an accent to the hair or the shading, but in this case I put some blue into the background, which helped to create more contrast with the highlight on his left cheek.

It is easy to keep fiddling at this stage and overwork or spoil the portrait. Take a half-hour break, stand back, reassess it and you will no doubt see that it is finished.

SHADING, TONE AND FORM

Shading creates tone and form, making the flat two-dimensional surface appear three-dimensional. It is usually added after the outline drawing stage of the portrait has been completed. The lines, marks or areas of shading should be built up slowly and systematically, serving to enhance what is there rather than be intrusive.

SHADING TECHNIQUES

These techniques apply whether you are using pencil, charcoal or pen and also coloured media such as pastel pencils, coloured pencils and pastels. With chalky media, you can of course smudge the hatched lines to create a softer, blended effect.

Many other marks can be used for shading. How you choose to interpret a particular texture or surface depends on the type of portrait and no doubt with practice you will develop your own intuitive shorthand.

Hatching This is shading using a series of parallel lines. How close or far apart they are will determine the degree of tone. They can describe a detail or cover the whole side of the head to harmonize a larger area. The lines can be applied in any direction.

Cross hatching Added over hatching lines, cross hatching is usually made at a different angle to the initial hatching lines (see examples opposite). Several layers can be added, altering the angle each time to create a really dark tone.

Contour hatching A variant of hatching, in which the lines are curved to accentuate the shape of a form.

Smudging Smudging pencil, pastel and charcoal is an effective way to tone a large area. You can use a tissue, your finger or a tortillon. Highlights can be 'lifted out' or erased from a dark background with a shaped kneadable eraser or an electric eraser.

Stippling A series of dots or dashes used with pen and ink. Stippling is a useful technique when a greater variety of marks is required to create texture and tone.

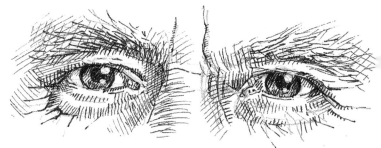

TWO EYES *Pen and ink*

Hatching and cross hatching have been used to create shading. The lines go in a variety of directions, suggesting the contours of tough, weather-beaten skin.

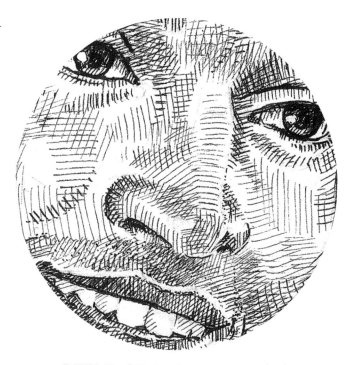

DETAIL OF BASHIR *Pen and ink*

Here contour shading curves around the bridge of the nose and nostrils, helping to define these features. Tone and form are shown through greater or smaller spaces between hatching lines.

Shading techniques with pencil

The degree of shading you build up with the techniques described opposite will depend on what grade of pencil is used, how close the lines are and how much pressure you apply. Using a softer pencil, such as an 8B, the hatching can be smudged with a finger or cotton bud to create a more diffuse, denser tone.

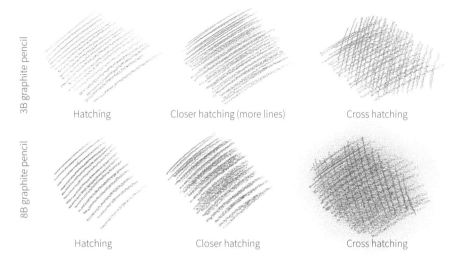

3B graphite pencil

| Hatching | Closer hatching (more lines) | Cross hatching |

8B graphite pencil

| Hatching | Closer hatching | Cross hatching |

Shading techniques with pen

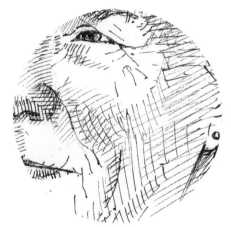

Hatching and cross hatching with a fibre-tipped pen creates harder lines than pencil, good for reflecting the older skin, as shown to the left. Some longer hatching lines cover the side of the cheek, unifying this whole plane.

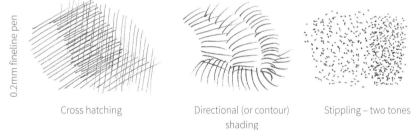

0.2mm fineline pen

| Cross hatching | Directional (or contour) shading | Stippling – two tones |

Shading techniques with charcoal

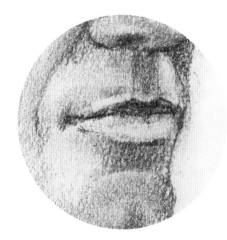

When using charcoal, a combination of drawn and blended marks can be used to represent the outline of the features and shading. Great depth of tone is possible.

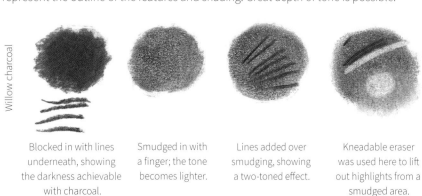

Willow charcoal

Blocked in with lines underneath, showing the darkness achievable with charcoal.

Smudged in with a finger; the tone becomes lighter.

Lines added over smudging, showing a two-toned effect.

Kneadable eraser was used here to lift out highlights from a smudged area.

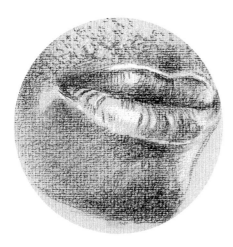

Shading techniques with pastel pencil

Pastel pencils are harder than charcoal so a sharper effect with more contrast can be achieved. In the monochrome example to the left, I added the highlights with the white pencil after establishing the shape of the mouth. I then switched back to the black pencil to add depth and tone, dotting in the stubble on the top lip with the tip of the pencil.

Pastel pencils lend themselves well to dry blending – that is, you can build up subtlety of hue by hatching and cross hatching with different pencils in combination. Below are some examples which might be used for flesh tones.

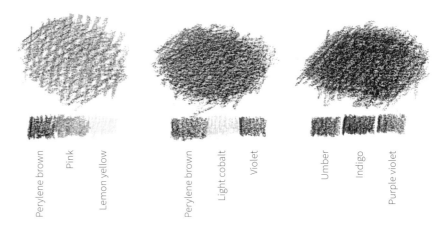

Perylene brown / Pink / Lemon yellow

Perylene brown / Light cobalt / Violet

Umber / Indigo / Purple violet

Shading techniques with soft pastels

When soft pastels are used on the rough side of tinted pastel paper, several pastels can be used together to create colour and texture. In the example to the left, the subject's hair has been made with open strokes whereas the pastel on his forehead has been blended for a softer effect.

Examples of soft pastels on white paper. The lower part has been smudged to achieve a softer effect.

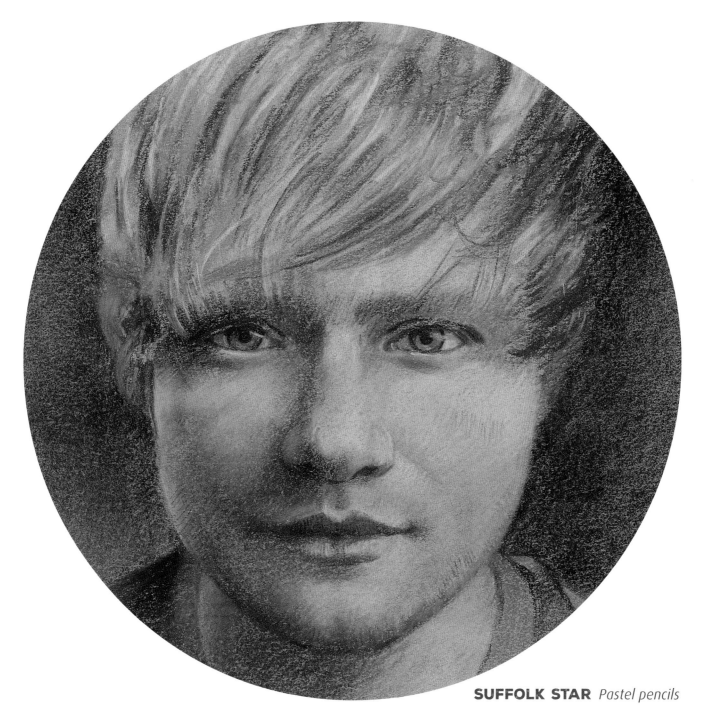

SUFFOLK STAR *Pastel pencils*

Shading techniques with pastel pencils

Pastel pencils allow you to combine pastel and pencil shading techniques. For the texture and flow of the hair, some pastels pencil marks (see right) have been overlaid and left as open, whereas I have blended the pastels on the skin for a smoother effect.

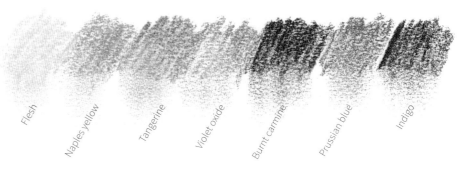

Flesh Naples yellow Tangerine Violet oxide Burnt carmine Prussian blue Indigo

A selection of colours used in the portrait above.

SHADOWS AND HIGHLIGHTS

Country singer

There are two types of shadow shown in this place: core shadows, such as the shadow under the nose or the side of the cheek; and cast shadows – those falling across the forehead from the fronds of her hair, or the ones cast from the long eyelashes. Both types are valuable in describing the shape of the surfaces they fall upon.

1 Draw the outline lightly using a black pastel pencil.

2 Next, put in the highlights with a white pencil.

3 Develop the lights and darks alternating with the black and white pencils. Use black in the background to outline the hair – take particular care when adding the background.

4 Having established the highlights and shadows, intensify the blacks, then the whites, and finally add her long eyelashes. The white pastel will not be effective over the back pastel, so if you need to add white at this stage, use a white soft pastel.

THE FINISHED PORTRAIT
Pastel pencil on red pastel paper

I enjoyed interpreting this high-contrast portrait using just black, white and red for maximum drama and impact.

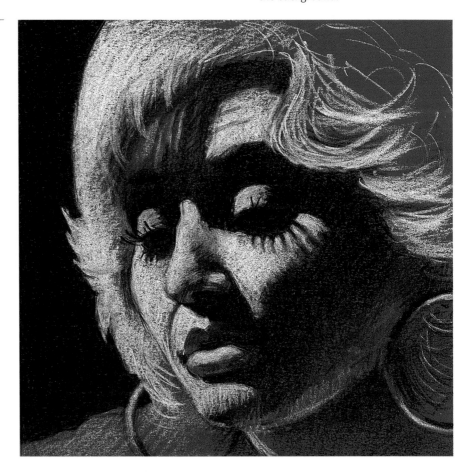

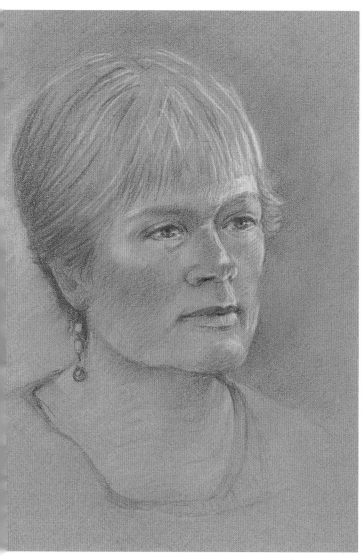

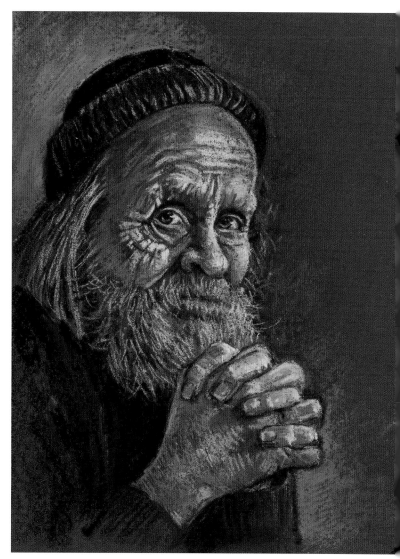

LYNNE *Pastel pencil on blue-grey Canson paper*

The directional lighting in Lynne's portrait brings out her high cheekbones, sharply defined nose and square jaw. Much of the left-hand side of her head is in subdued lighting, but I have introduced a little more colour to make it a more interesting sketch.

MAGNUS THE OLD CARPENTER *Soft pastel on Colourfix Burgundy texture paper*

Sometimes a hat is a useful aid in showing the curve and fullness of the head. This character has a strong brow ridge and rounded cheekbones. His hands are a significant part of this portrait, emphasized by the lighting. I was able to use the colour of the paper for the shadows, contrasting nicely with the highlights.

Dry colour effects

Colour can be built up in successive layers, so if you have a limited selection of colours you can overlay several colours to produce the desired hue.

I did this study of Tony from a photograph using a set of Derwent Procolour and Derwent Coloursoft pencils, but any range of coloured pencils or watersoluble pencils, used without water, would work equally well. Remember to keep your pencils sharpened to a good point!

TIP

Colours in order of use: dark terracotta (Coloursoft), burnt umber, brown ochre, blush pink (Coloursoft), sunset gold, primary red, foliage green, ivory black, heather, blue violet lake, spectrum blue, imperial purple.

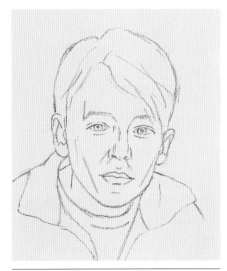

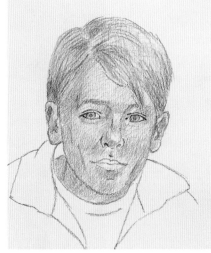

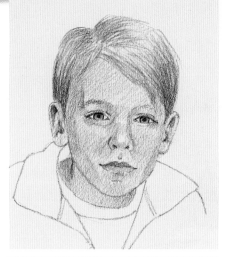

1 Use a reddish brown (dark terracotta) pencil for the outline drawing. The plan is to add light layers rather than go in too heavy too soon.

2 Darken the eyelids, irises and pupils using burnt umber, then use a combination of the browns, yellow and ochre in the hair and some reddish brown over the ears. Next, work across the face lightly with pink, red and yellow. Emphasize the red in the tear ducts, cheeks and ears and avoid the very lightest parts.

3 I aim to get the eyes looking reasonably lifelike at this stage. Use foliage green with a touch of brown ochre for the irises, outlining them and adding the pupils with ivory black. Lift out a small highlight using the electric eraser and add colour to the lips with the red pencil. For the shading at the side of the head and around the neck, use a heather and blue violet.

THE FINISHED PORTRAIT OF TONY *Coloursoft pencil*

The final stage was to tackle the clothing – black for his fleece and spectrum blue for the t-shirt. I kept this detail quite simple so it did not distract from the portrait. Having finished the clothing I looked at the head again and thought that it needed more contrast, so used purple at the corners of the mouth, round the folds of the eyes and to intensify the black fleece behind the neck.

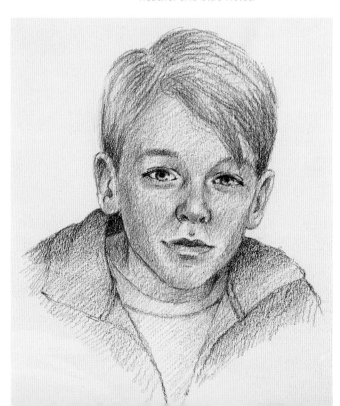

RICHARD *Soft pastel on grey pastel paper*

The constraints of time when working from life often lead to a much looser approach than when working from a photograph. This can be an advantage. The pastel marks here are open and unblended; colours lie alongside one another with the tint of the paper showing through in many places, as in the hair, serving as a cool mid-tone. The solid bright green background makes the left-hand side of the face (the model's right) look darker by contrast and increases the solidity of the head.

ERIC *Pastel pencils on dark brown paper*

The dramatic uplighting across Eric's head is captured here using a yellow pastel pencil. The hat and jacket were drawn in outline with a black pencil and the purple added in the background, encompassing the form to make it look like a dense mass. This short study took about twenty minutes.

HAIR AND FACIAL HAIR

When drawing the hair, treat it as a general mass, emphasizing the flow and movement or texture. Drawing a few wisps of stray hair here and there can create a more natural look and if single strands or clumps stand out, draw these individually.

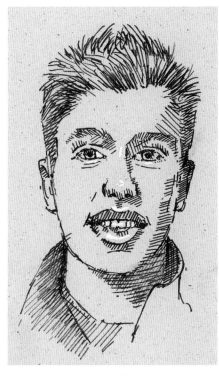

TOUSLED STRAIGHT HAIR
Brush pen

Directional marks and the varying weight of line create this tousled look.

WAVY HAIR *Charcoal*

Using charcoal sticks with directional strokes and some selective shading, I have quickly created blond wavy hair.

SPIKY HAIR *Felt-tip pen*

Short, straight directional marks create this youth's spiky hair style. When using felt tip pen, allow the white of the paper to show through.

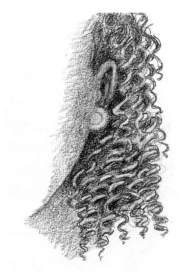

SHORT BLONDE HAIR
Coloured pencil

I outlined the mass of the hair in pale brown, then built up flowing lines following the direction of the hair before adding yellow or dark brown to create the thickness and flow of this hairstyle.

TIGHT CURLY HAIR
Coloured pencil

I started by drawing the outer mass of the hair with curly twisting lines, then worked back to the head, filling in and leaving a few curls lighter to catch some highlights, which gave it movement.

LONG AUBURN HAIR
Coloured pencil

Using a reddish brown pencil, I sketched the main tresses of the hair, letting some appear to flow over the top of others. I added several shades of brown, orange and yellow ochre to colour in the mass, then used a dark brown and black in between the main tresses to add depth and shading.

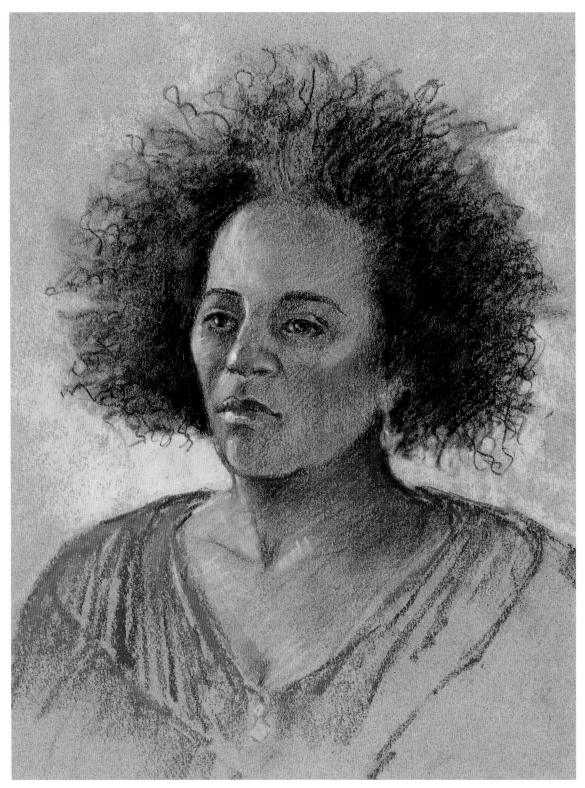

MESKY *Pastel pencil*

This model's stunning afro hairstyle was quite challenging to draw! I worked away from the head with black wiggly lines to build up the texture of her hair. A few accurately drawn details at the outer edges are all that is needed to suggest a whole head of curls. Around the temple and forehead, the pastel was blended into the skin to avoid it looking too harsh.

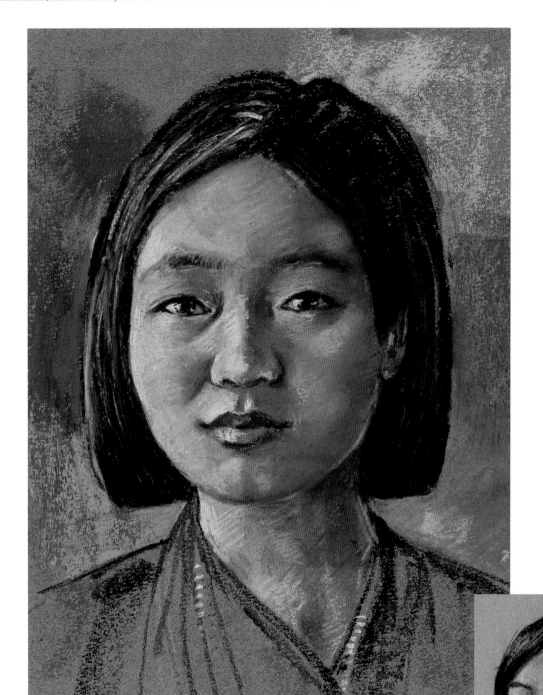

JIOA *Soft pastel*

To balance the very dark tones of the hair, I've used a black pastel pencil to draw her eyes and eyebrows, with touches also in her clothing. I've also brought the blue of the background and the red I used in her skin tones and lips into the clothing too. This all helps to produce a harmony throughout the painting.

HIGHLIGHTS ON BLACK HAIR *Soft pastel*

Highlights on black shiny hair are very often blue or reflect surrounding colours. Black and dark greys were used to describe the flow of the hair, then light grey, blue and a touch of pink were used for the highlights.

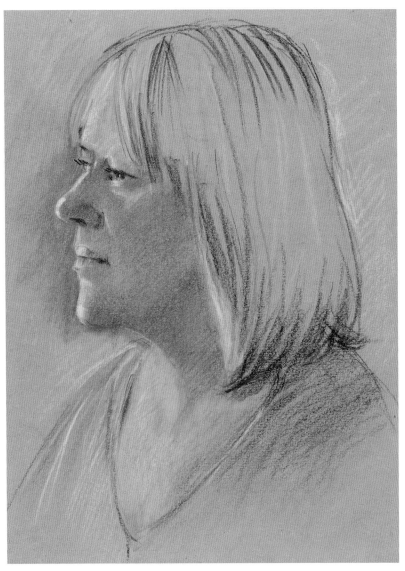

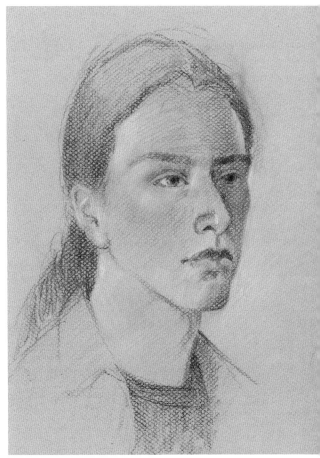

ROBERT *Pastel pencils on blue-grey pastel paper, rough side*

I drew the outline of Robert's hair, darkening the far side round the temple, the near side above and behind his ear, and the ponytail. It is important to make the hair look like part of his skull rather than standing out like an add-on.

ELIZABETH *Pastel pencil on buff pastel paper*

Using this colour of paper, only a few marks were needed to describe both the colour and shape of her hair. Strong lighting produced sparkling highlights across her lower lids, nose, lips and chin; to enhance these, I darkened the background behind her profile.

Facial hair

As with hair, moustaches and beards should be treated as a three-dimensional mass. Avoid labouring over numerous individual strokes, but add a few selectively round the mouth and the outer edges to add both texture and shape.

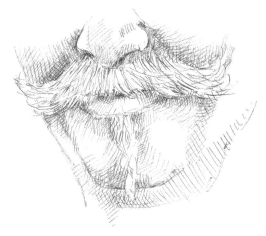

NIEL'S MOUSTACHE *Ballpoint pen*

Deliberate darkening around the moustache with hatching and cross-hatching marks makes the moustache stand out and appear light. Directional curving lines imitate the growth of the hair down the centre of the chin.

ALBERT *Pastel pencil*

White and black pastel pencil, used quite sparingly, were ideal to create this old man's white hair and beard. I darkened the background behind his head so that his white hair stood out more.

DIMITHRA *Pastel pencil*

I used a black pastel pencil for Dimithra's beard, creating solid black round the jawline but using it more sparingly around the chin area. His hair was a dense black, but I drew individual directional lines to suggest movement and highlights.

ABDUL *Fibre-tipped pen*

Abdul's scant moustache is stippled in with a series of dots with the 0.5mm pen, then hatching lines added to darken the upper lip slightly. His beard is built up with a series of short strokes.

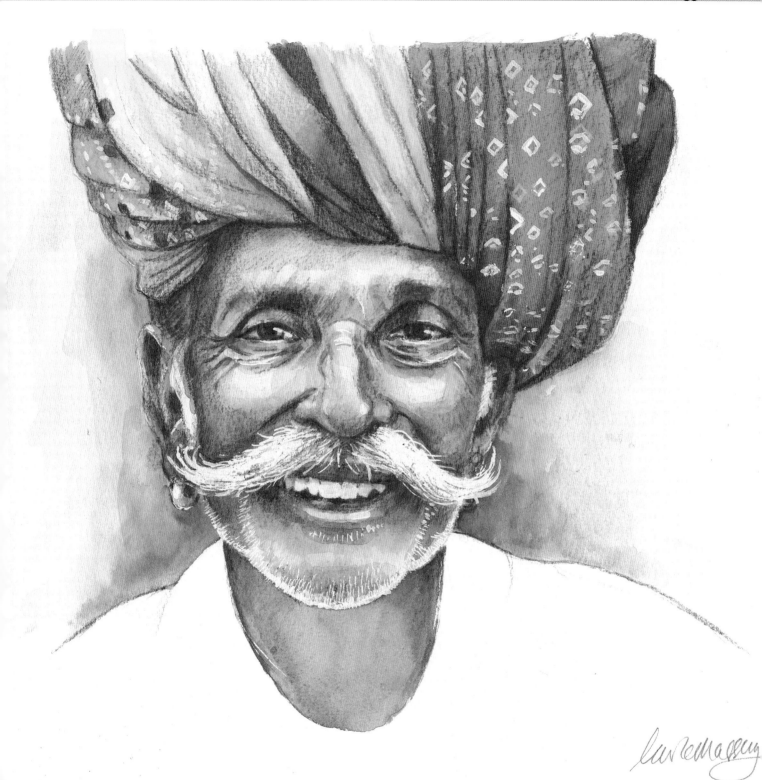

INDIAN IN TURBAN *Watersoluble pencil*

*I used masking fluid applied with a dip pen to reserve the white hairs of the
moustache, the sideburns and the beard. Having added successive layers
of colour which I wetted, I removed the masking fluid and then added some
shading with dry colour to make it look more natural.*

CHARACTER AND EXPRESSION

An amazing array of facial expressions are created by the many muscles pulling and pushing the facial tissue around. Subtly changing the shape of the eyes and mouth in particular can make striking differences to an expression – sad, happy, frightened, quizzical, or shocked.

The following pages show examples of just a few of the many expressions of which the face is capable. A lot of photographs are taken with the teeth showing, but the teeth can be hard to do. Try to get a smiling, happy face (as below left) with a closed mouth.

TIP

Look through a newspaper and sketch as many different facial expressions as you can. They may not make what we would think of as ideal portraits, but they provide an excellent exercise in observation.

CONTENTMENT *Inktense pencils*

A smiling, happy expression (without the teeth being revealed). His eyes still reveal a smiling expression even with his mouth covered.

DELIGHT *Charcoal and pastel pencil*

The inclined pose creates foreshortened features: the eyes, looking down, may look closed. To avoid this, you can make sure the iris is apparent.

PLAYFUL *Graphite pencil*

Three sketches of a cheeky little lad whom I was trying to 'snap' for a commission.

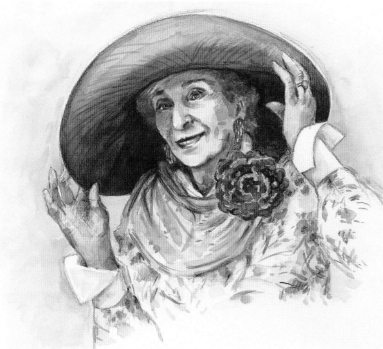

THEATRICAL *Watersoluble pencils*

A very theatrical lady, Jilly was only too willing to don the hat with matching accessories and strike this charming pose for her portrait.

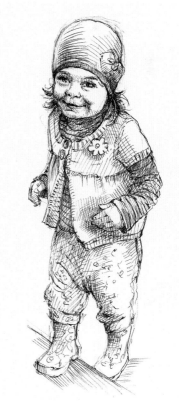

COY *Pen and ink*

I love this little girl's shy pose, captured wearing her cloche hat and favourite wellies.

AMUSEMENT *Fibre-tipped pen*

This man's broad toothy grin pushes up the cheeks, compacting the eyes. Strong sunlight casts interesting patterns across his face.

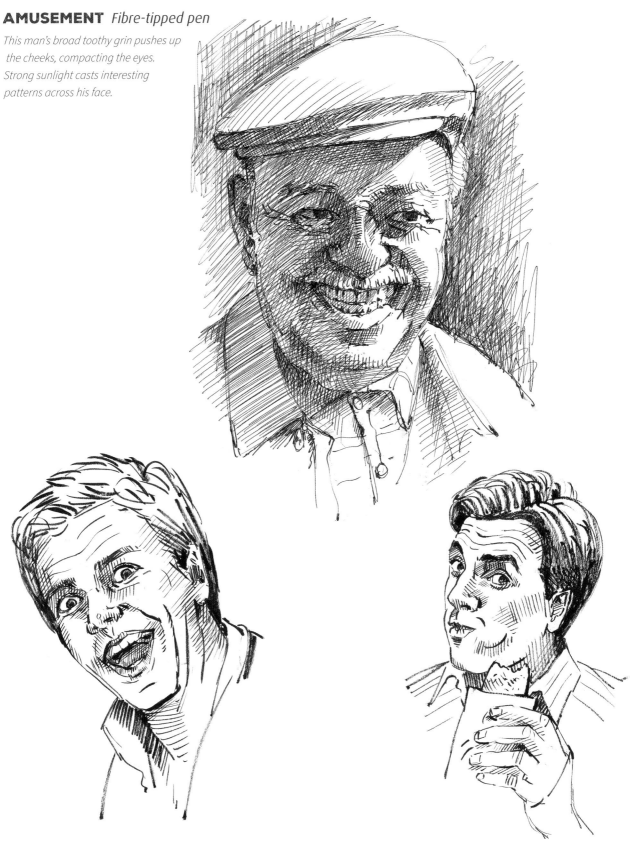

SURPRISE *Pen and ink*

The open mouth, raised eyebrows and the white of the eyes showing above the irises all help to create this look of astonishment.

IT'S TASTY! *Pen and ink*

Raised eyebrows, and the mouth distorted because of the bulging cheeks make a comical expression.

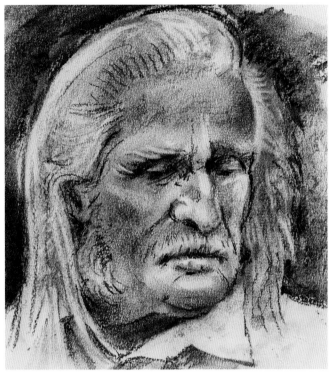

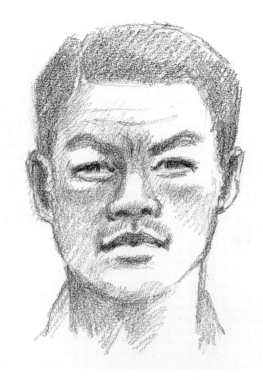

DISDAIN *Charcoal*

I spotted this man at a fair in Brittany and with his long hair, sideburns and moustache he makes a good subject, quickly sketched back in the studio in brown pastel.

INTENSITY *Brown charcoal pencil*

A direct, slightly squinting look from this man who perhaps did not want his photograph taken!

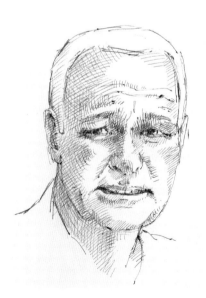

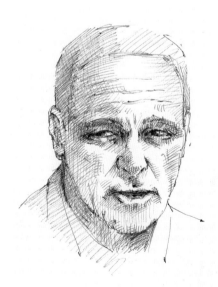

Far left:

DISAGREEMENT *Ballpoint pen*

Left:

CYNICAL *Ballpoint pen*

It is a useful exercise to make several sketches of the same person with different expressions; I snapped these images from the television, a useful way of gaining source material.

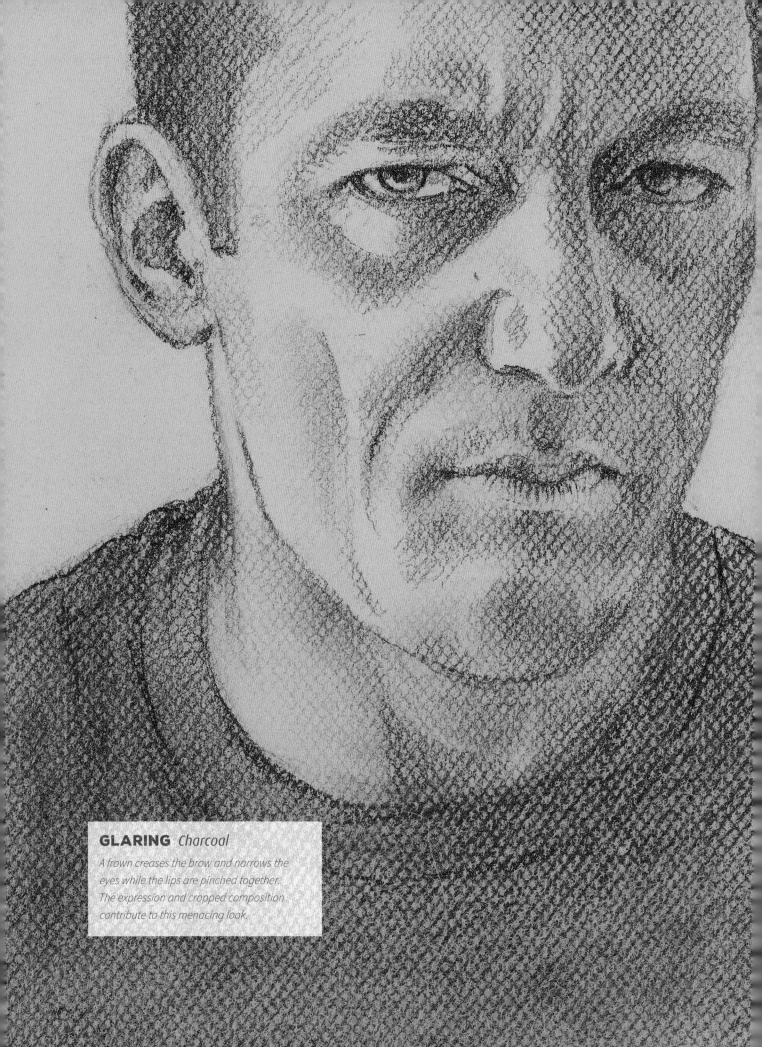

GLARING *Charcoal*

A frown creases the brow and narrows the eyes while the lips are pinched together. The expression and cropped composition contribute to this menacing look.

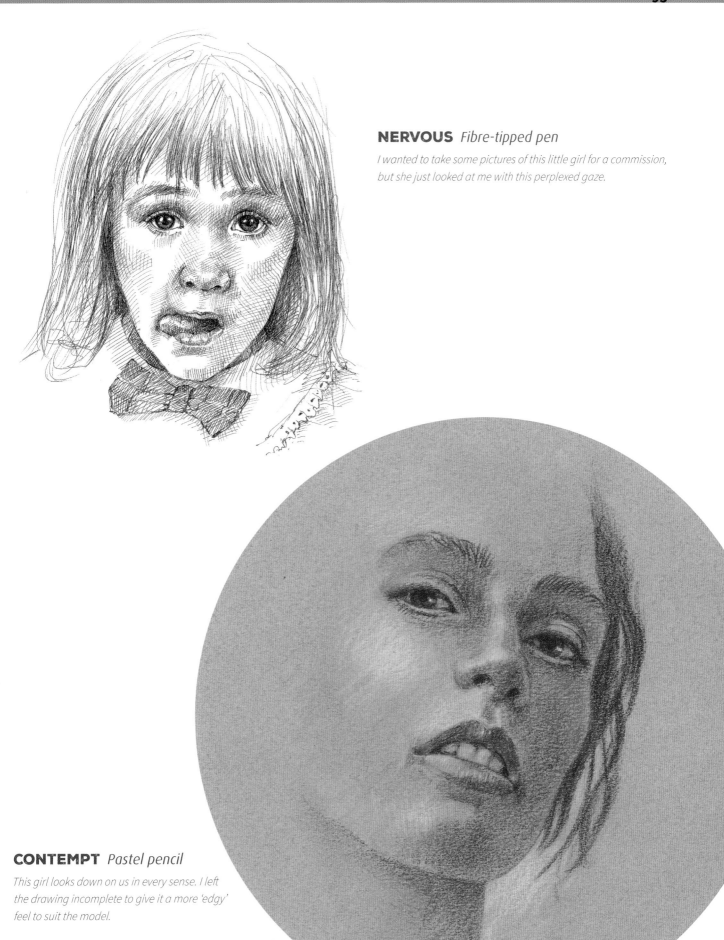

NERVOUS *Fibre-tipped pen*

I wanted to take some pictures of this little girl for a commission, but she just looked at me with this perplexed gaze.

CONTEMPT *Pastel pencil*

This girl looks down on us in every sense. I left the drawing incomplete to give it a more 'edgy' feel to suit the model.

MOVING ON

SKETCHING

'The sketch is the product of enthusiasm and inspiration, while the picture is the product of labour, patience, lengthy study and consummate experience in art.' – **D. Diderot, 1767**

'[A sketch is] the intermediate somewhat between a thought and a thing.' – **Samuel Taylor Coleridge**

If you want to improve your drawing, then sketching should be your daily exercise. Sketching will hone your observational skills, increase your speed and improve your visual memory. A sketchbook is your own personal record where you can experiment, take risks, make mistakes and not worry too much about the results. Like a photograph album, it can be a document of people, places and events in your life that interest you.

Anything and everything can be included – whatever appeals to you. It is an aide-memoir and invaluable reference that enables you to try out new ideas and mess about with materials and subject matter before committing to your masterpiece. Most importantly of all, it is great fun!

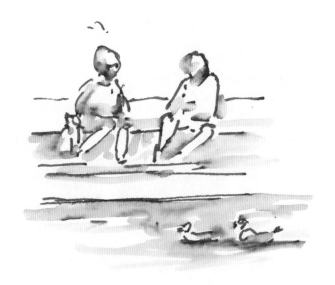

FEEDING THE DUCKS
Watersoluble pen

ERIC SNOOZING *Graphite pencil*

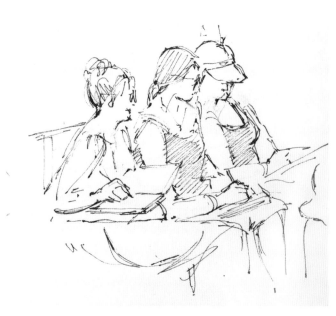

ARTISTS SKETCHING *Pen and ink*

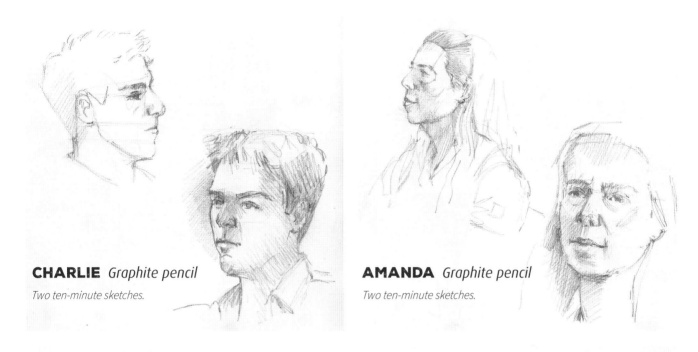

CHARLIE *Graphite pencil*

Two ten-minute sketches.

AMANDA *Graphite pencil*

Two ten-minute sketches.

THE BOWLS CLUB *Pen, ink and watercolour*

A series of sketches made while watching the bowling match.

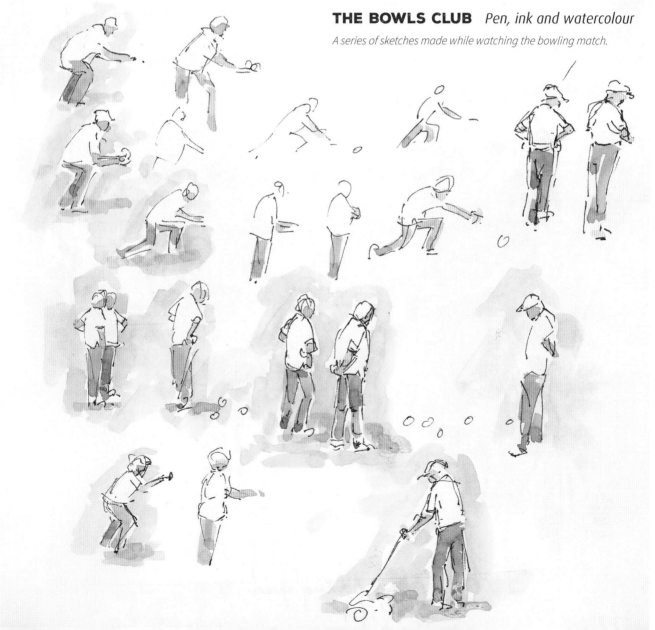

USING PHOTOGRAPHS

No matter how accurate your visual memory, it is very difficult to retain the image of a particular fleeting moment, facial expression or lighting effect. Working from photographs is sometimes thought to be 'cheating', but providing you are not copying slavishly, it can be an extremely good source of reference.

Artists who prefer to work from life often use photographs for an accurate reference for details such as clothing, jewellery and background. Using a 'pre-prepared' image also allows you precise positioning on the working surface.

Although working from life is arguably the best way to observe and record the character of a person, there are many times when photographs really excel; the camera can capture a precise moment in time, a fleeting look, smile, laugh or a special event which cannot possibly be otherwise recorded. I love this liberating aspect of photography, of the frozen expression. Some examples of portraits from such photographs are shown here.

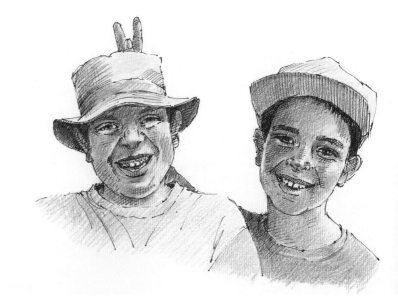

VICTORY JOKE *Ink and coloured pencil*

These cheeky boys played up to the camera and I love the sheer delight and mischievous grins on their faces. I rarely use ink for drawing children, but here I wanted to convey the effect of sunlight creating strong contrast on their faces. I've added coloured pencil to the ink drawing.

ACCORDION PLAYER, BRITTANY *Coloured pencil*

It was quite a surprise to see this young musician fronting a band. I took several photographs and although the results were quite dull, I could glean enough detail for this study back in the studio.

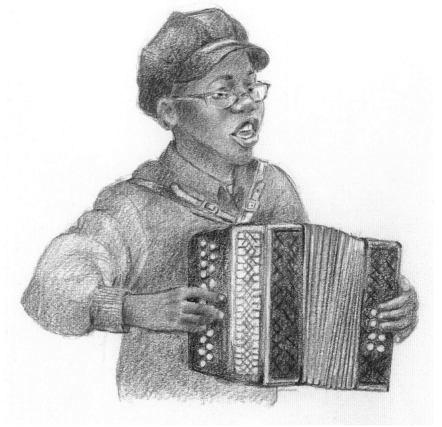

ANN AND STEWART
Pen and charcoal pencil

I like to take natural photographs that catch people unawares. Here, Ann is engrossed in a conversation across the room but Stewart has glimpsed my camera and is casting a wry smile.

TWO PALS *Graphite pencil*

Two friends, sharing a tale, both wearing hats.

Using a grid to resize a photograph

This simple technique for enlarging or reducing an image using a prepared grid provides a quick and sure way to help position the features accurately, whilst maintaining the looseness of freehand drawing. To make the grid, you will need tracing paper, a ruler, and a pen or pencil. A set square is an optional – but useful – addition.

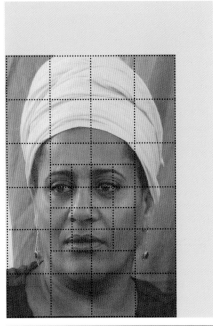 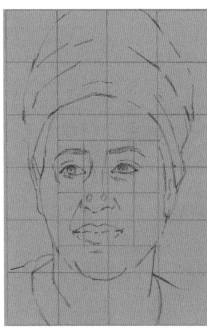

1 Cover the photograph with a piece of tracing paper, secured at the top and draw a square grid to cover the area of the image you wish to enlarge. I made my grid 2.5cm (1in) over the 10 x 15cm (4 x 6in) photo. I halved the size of the grid over the features to get more detail.

2 Draw an enlarged square grid (be sure to include the smaller grid over the features) on the paper. I doubled my grid size to 5cm (2in), and 2.5cm (1in) over the features, but you can choose whatever size is relevant to your paper and drawing or painting medium. As I was going to use soft pastels for the portrait, I drew my enlarged grid with a light brown pastel pencil.

3 Using the gridlines on the photo as a guide, replicate the outline of the image into your paper. For example, starting on the left side of the headdress, I marked the points where it crossed the grid lines, then joined them up to form the curve. Once the drawing is complete, you can carefully erase the grid lines.

Opposite:
MAYA *Soft pastel on Moonstone Canson Mi-Teintes paper*

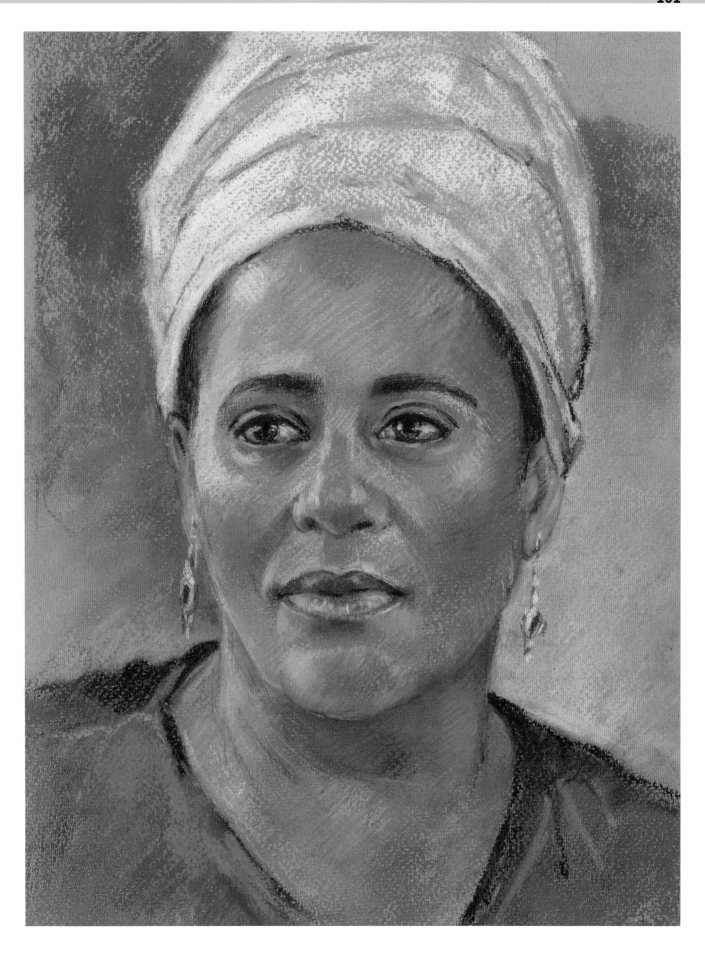

ROSIE

I did lots of sketches of Rosie, and took some photographs, one of which I have used to make an enlarged photocopy. This is a relatively quick and simple way to produce an accurate representation. Even though you are tracing, each stage should present a fresh opportunity to observe and explore the subject, rather than it being a mere mechanical process. Keep referring to the original photograph which will have clearer detail than the photocopy.

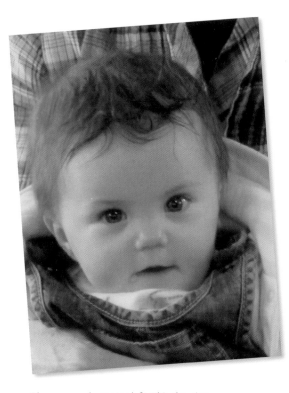

The source photograph for this drawing.

1 Tape the tracing paper to the photocopy at the top. Now make an outline drawing of the image in pencil, leaving out the shadows. Refer to the original photograph for any details which may have been lost in the photocopying process. Mark the position of any highlights. I have changed her clothing a little, to reveal more of her neck.

2 Secure your pastel paper, smooth side up, to the board with masking tape. Elevate the top of the board to form a sloping work surface. Have your reference photograph nearby, squared up to the paper. To transfer the image, tape the tracing to the top of the pastel paper. Slip the transfer paper underneath (dark side down) and using a ballpoint pen, draw over the pencil lines. Lift the tracing to check the image is being transferred successfully, and if necessary apply more pressure, but be careful not to damage the surface of the paper. Refer to the original and adjust the image to achieve a better likeness.

TIP

Work very carefully. You may think that tracing a photograph is a foolproof format for producing an accurate portrait; however the slightest mark, highlight or shadow in the wrong place will alter the likeness.

3 Start by using the white pastel pencil to draw in the sharpest highlights – in the eyes, on the nose and cheeks; it is essential to do this now as white pencil is not effective over black pastel. Next, switch to the black pastel pencil to redraw the outline. Use directional marks to mimic the growth of the hair and draw in the eyebrows with delicate strokes; a key concept when drawing a child's portrait.

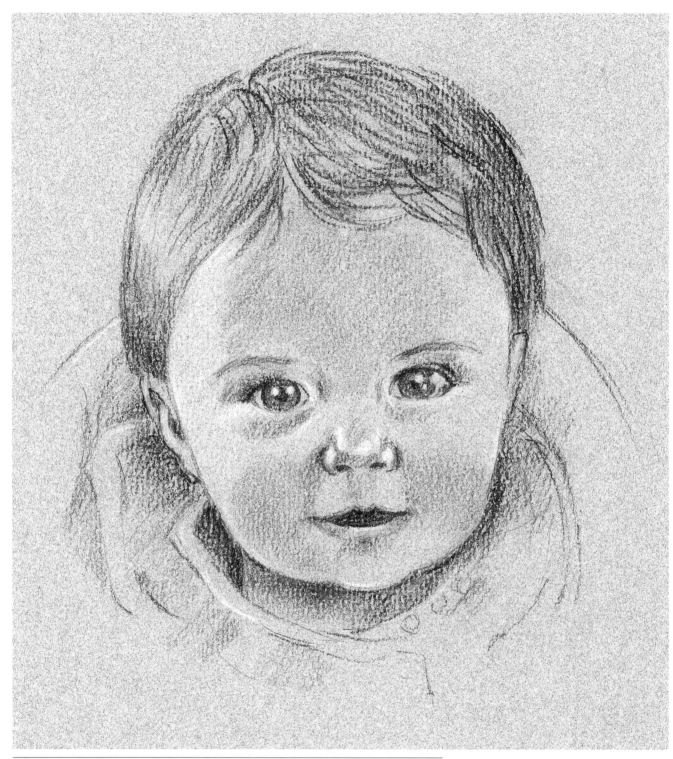

4 Increase the tonal contrast by shading in the light areas with white pastel pencil, and then the dark areas with black pastel pencil, allowing the grey paper to denote the mid-tones. Take out highlights with the kneadable eraser, and if there are areas that are too dark, lift them out with a dabbing action. Use the tortillon to blend small dark areas such as the eyes, the mouth, the hair and those on the clothing.

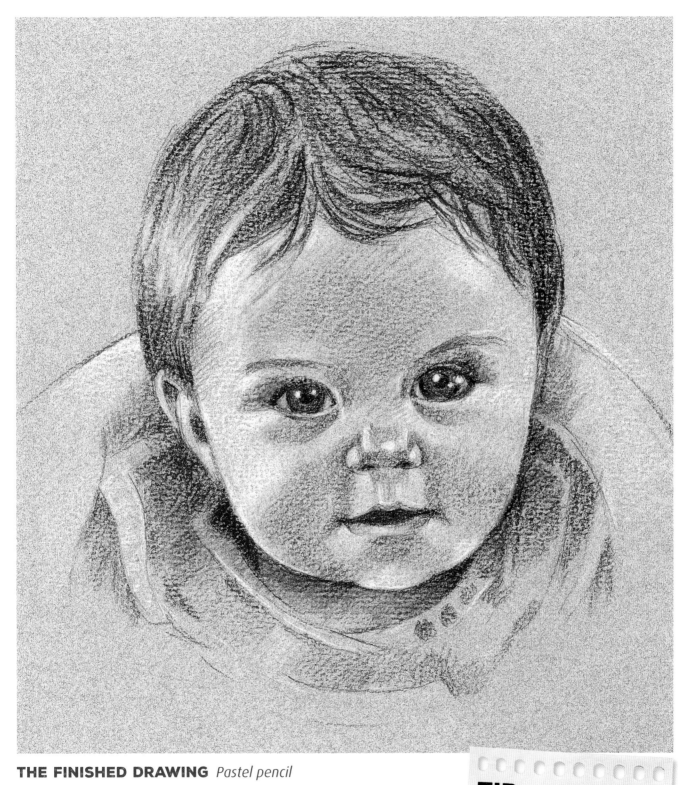

THE FINISHED DRAWING *Pastel pencil*

To complete the portrait, add sufficient shading detail to the clothing to suggest the collar and neckline without it becoming overaccentuated. Increase some of the highlights to improve the form of the head and, lastly, reapply the white highlights in the eyes. To help prevent smudging, spray the picture lightly with fixative, then cover with a sheet of paper for protection once the fixative dries.

TIP

Walk away when you think you are nearly finished and see if you really need to add anything more.

DRAWING FROM LIFE

WORKING WITH A MODEL

If you are working with a model, here are some considerations you may find helpful.

- Discuss suitable clothing for the model to wear beforehand, e.g. a shirt or blouse, preferably not too dark or highly patterned.

- Choose a suitable chair, which will dictate the pose. An armchair, for example, will give a more relaxed pose than an upright chair which is better for formal poses.

- Decide on an appropriate plain or draped background, which can be light or dark to contrast with the model's skin tone and clothing.

- Consider the lighting. It should be from one source, slightly diffused and slightly above the model's head height. Artificial lighting is more controllable than daylight.

- Ask the model to look at a point in the room slightly above your eyeline.

- Give the model a timescale for the sitting(s), e.g. a two-hour session with five-minute breaks every twenty or thirty minutes.

- Position the model so that you have a three-quarter view and you are either looking slightly up at him or her, or are at the same height. You should be about 2m (6ft) from them.

- Chatting to the model will not only allow you to gain more of an insight into their character, but it will prevent their facial muscles sagging.

- Take photographs so you can work on the portrait between sittings; this is particularly useful for working on details such as clothing, hairstyle, jewellery or background details.

Avoiding the set expression

A sitter can, after a while, lapse into a dazed or set expression (or even fall asleep), which can result in a dull or lifeless appearance to the final portrait. A good way to avoid this is to talk to them while drawing – if you can concentrate on both! Also, ask them to look at the fixed point only when you want to paint their eyes.

TIP

Having the television on for your sitter to look at over your shoulder, or some music playing (providing it is not soporific!) will help to keep them alert; or you could set up a mirror behind you so they can see the drawing or painting in progress.

HAYLEY *Charcoal*

Charcoal is an effective medium for a short study as the tones can be added quickly, lines altered with the smudge of a finger and highlights easily lifted with a kneadable eraser.

KRISTINA *Conté stick*

Having lightly positioned the features with sanguine, before going any further I put in the highlights with white, then finished the drawing. I added touches of black to the eyes, mouth, hair and neckline, and blocked in the background to create depth.

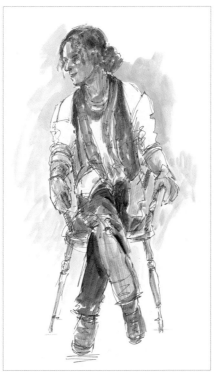

JOHN SEATED *Pen and wash*

This full figure pen and wash sketch was done quite quickly. John sits upright in the wooden chair, turning his head away to chat to someone off to the left of the picture. His body language is confident and alert.

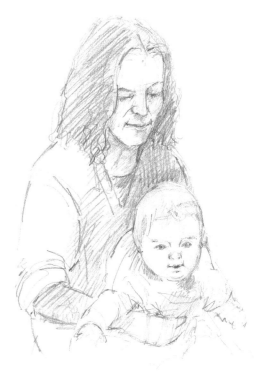

SARA AND ROSIE *Graphite pencil*

The relative size of heads in a portrait is important – an adult's head will be larger than a child's, but the proportions detailed above remain applicable.

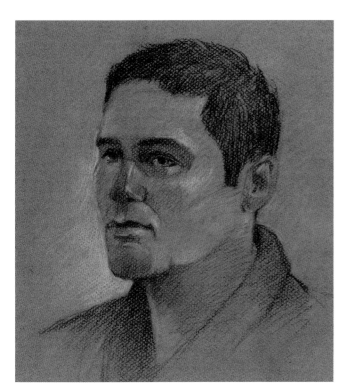

GYURI *Pastel pencil on blue-grey pastel paper*

One of the delights of working with a model is the ability to see the subtle colour of the skin, eye and hair colouring that is often dulled in a photograph. I have used yellow and reds where the light plays across Gyuri's strong features, contrasting with the cooler lilacs, purples and blues for the shaded side.

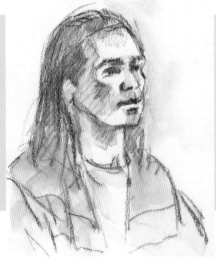

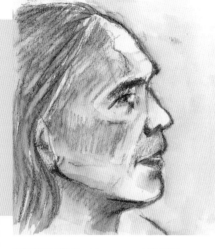

**THUMBNAIL SKETCHES
OF COLIN** *Watersoluble pencils*

*Top left: Head and shoulders,
three-quarter view.*

Top right: Square format, profile

Bottom left: Head only, three-quarter view

Bottom right: Full figure, yoga pose

POSE AND BODY LANGUAGE

So far in this book we have concentrated on the head and the features, but in this section we also consider pose and body language, which can set the mood of the portrait and contribute subtle and intuitive emotions. The way someone sits or stands can portray character. Body language can describe attitude, expression and reaction to the viewer or their surroundings, so it is worth taking time to consider how to pose the sitter and how much of the body to include.

When I drew Colin, I made a series of sketches to decide on the best pose and format (landscape or portrait) using a viewfinder. His yoga pose was interesting but I decided to do a study of his wonderful profile, which you can see on page 67.

On the opposite page is a selection of graphite pencil thumbnail sketches in different poses and formats. Use a viewfinder to decide on format – landscape or portrait view – and how much of the sitter to include.

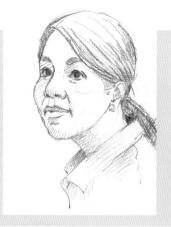

ELLEN

A typical three-quarter view head-and-shoulders pose; a nice balance within the portrait.

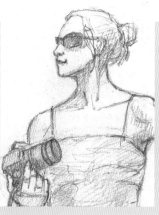

THE PHOTOGRAPHER

Here the low viewpoint adds drama to the composition, enhanced by strong light and colours.

OLD FISHERMAN

I came across some old photographs of fishermen in a local museum and thought this figure would make a good monochrome study. His stance is composed yet casual, as he poses for the camera. I've cropped it below his knees so I could get more detail in the upper body.

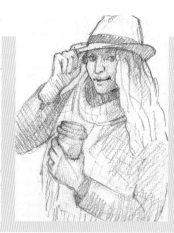

NEW HAT

With her shoulders tilted towards us and tipping her hat in a jaunty pose, the body language of this subject signals humour and fun.

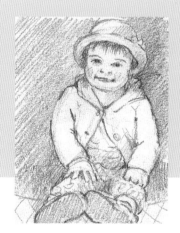

HIDING

Little children have a particular charm and body language of their own; wearing her hat and wellies, this toddler poses in an arbour, hand on knees and feet outstretched.

HAPPY FAMILY

The three touching heads confirm the love and happiness portrayed in this landscape composition.

KIWI GRANDMOTHER

I chose a landscape format here to match the squareness of the figure leaning, chin on hand, on the table.

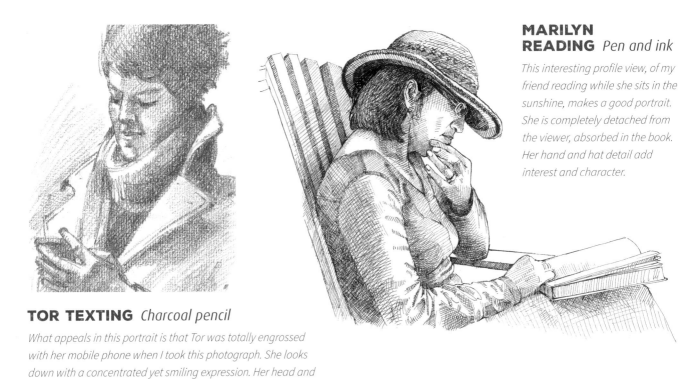

MARILYN READING *Pen and ink*

This interesting profile view, of my friend reading while she sits in the sunshine, makes a good portrait. She is completely detached from the viewer, absorbed in the book. Her hand and hat detail add interest and character.

TOR TEXTING *Charcoal pencil*

What appeals in this portrait is that Tor was totally engrossed with her mobile phone when I took this photograph. She looks down with a concentrated yet smiling expression. Her head and body are cropped to exaggerate the concentration.

NEW HAT *Pastel pencil*

I snapped Charity trying on her new hat and liked the cheeky expression on her face.

TINA SEATED *Pastel pencil*

The focal point of this portrait was more about the intense light catching her far arm resting along the sofa than the portrait itself.

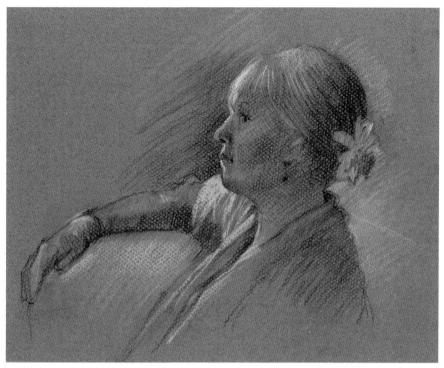

JAY *Pastel pencil*

Jay's direct gaze reflects his open, upfront personality. This was a half-hour study from life. He chose to pose in his chef's gear, which I like.

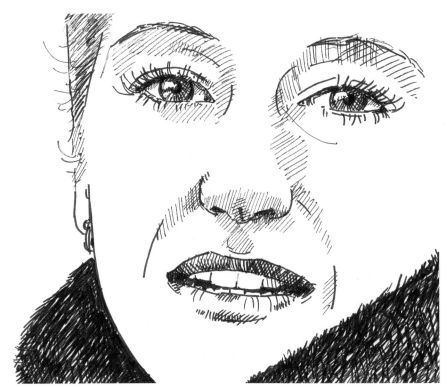

CLOSE-UP
Fibre-tipped pen

An assured, direct pose. This young woman looks as if she is talking directly to the viewer. I chose to crop the forehead and chin to create a big close-up view emphasizing the large eyes and partly open mouth, framed by the dark texture of the coat, which looks dramatic in pen and ink.

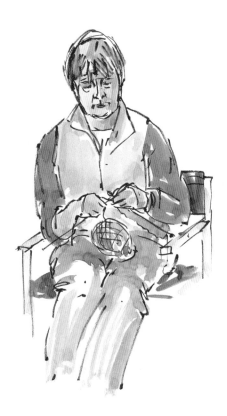

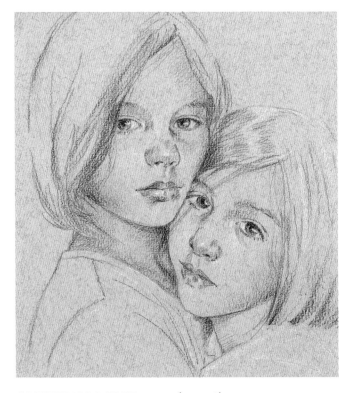

SISTERLY LOVE *Pastel pencil*

Gazing passively at the viewer, these young girls look serene and calm as they hug each other in a show of sisterly affection. It makes a charming study, which I have drawn using black and white pastel pencils on tinted pastel paper.

BRIDGET KNITTING *Pen and wash*

An informal, natural pose in pen and wash. Bridget looks down as she works, appearing relaxed and quite unaware of the viewer.

MY DADDY *Graphite pencil*

This intimate moment shared between father and daughter, the little girl looking intently at her Daddy's face, creates an enchanting study.

HEATHER AND DOG
Pastel pencil

I ran out of time to complete this portrait of Heather and her dog, but I was pleased I had managed to capture her calm expression and graceful pose.

COMPOSITION

One can be inspired by – and learn much from – the work of great artists, past and present. Studying them can show you how they posed their models; set up the lighting; what backgrounds they chose; and how they dealt with the layout or design of a painting. All of this together is termed composition. There are no set rules, but some guidelines may help if you are looking for ideas for your own portraits. I often do lots of small sketches, known as thumbnails. As well as helping to organize the composition, they help with balancing the tones, deciding on the format (landscape or portrait) and are a good way of practising before you start on the real thing.

THE GOLDEN SECTION

Traditional portraits were often based on the proportions of the Golden Section (also called the Golden Ratio), a system invented during the Renaissance to organize elements in a painting in an aesthetically pleasing and balanced way. The Golden Section divides up the surface according to a set of complex mathematical rules demonstrated in the sketch of a Rembrandt self-portrait to the right. The Golden Section is used here to direct the viewer to the left eye (his right), positioned three-eighths down and three-eighths in from the left. Where these lines cross is called the focal point.

This complexity of the Golden Section can be simplified into a more practical format of a one third–two thirds template, known as 'The rule of thirds'. Use this rule as a guide to position the figure pleasingly in a composition. The examples opposite, some of which were sketched from other artists' paintings as well as my own, may give you some ideas for using this rule as a guide when placing a half figure or full figure in your own work.

Positioning the head on the paper

The examples below show the best positions for a head-and-shoulders portrait. The rule of thirds is not so apparent here, but the placement of the head within the painting remains important. Set the eyeline above halfway, and leave space to the right or left of the head, depending on which way the model is looking.

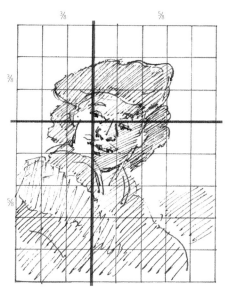

An example of using the Golden Section to help with composition.

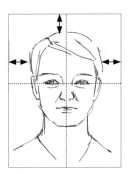

FULL FACE VIEW

The eyeline is above halfway, with equal spaces at the top and the sides of the head.

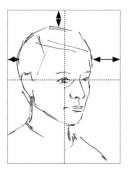

THREE-QUARTER VIEW

The eyeline is above halfway with more space to the right of the head, so the sitter appears to look into the space, rather than out of the picture.

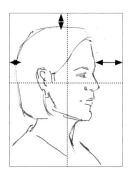

PROFILE VIEW

The head is positioned well to the left, so there is more space on the right.

A conventional half-body pose, showing the hands. The head and torso are rotated to the the sitter's left, turning towards the view.

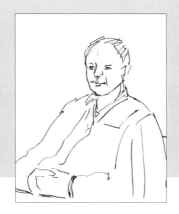

A formal pose showing the head and body in a three-quarter view, with the hands in a relaxed pose.

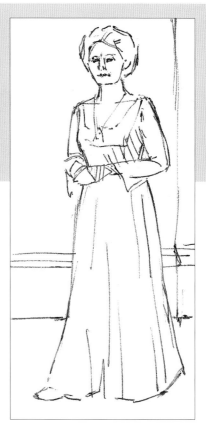

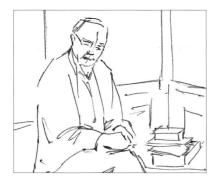

The figure sits framed against a window, with his books to one side on the seat.

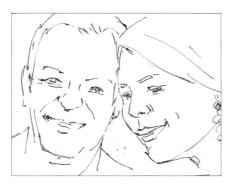

The composition, a close-up of two heads, shows harmony and togetherness.

A standing full figure in a long narrow format. Note the horizontal lines form a counterbalance to the vertical composition and anchor the subject down.

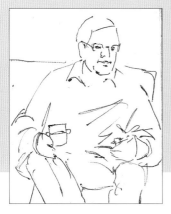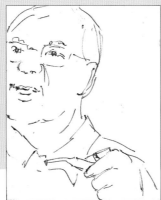

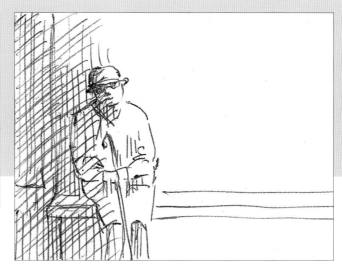

Here are two different views of the same model. In the left-hand pose he relaxes with his pipe and whisky. Although he looks out of the picture, the composition is balanced and there is sufficient detail to maintain the viewer's interest.

The right-hand composition breaks all the rules; our model looks out of the frame, and his head is cropped through, but the hand and pipe detail in the foreground draws the eye back into the picture. It makes a fascinating portrait and just shows that sometimes rules are there to be broken!

With the figure set to the left leaving a large space to the right, this is as much a statement about the old lady as it is a portrait of her. She sits demurely in half shadow; we don't know if she is waiting or watching, but the feeling is one of isolation and loneliness.

MEASURING WITHOUT A RULER

Judging distances and angles by eye is not always accurate, even for the most experienced artist. The brain often challenges what our eyes see, convincing us a distance is shorter or longer than it really is. The following simple ways of measuring will help you to evaluate accurately what is in front of you and can be used for drawing any subject.

Measuring angles

Continually cross-referencing different points on your artwork is a sure way to increase accuracy. For this process, line up your working surface so you can easily glance from the model or photograph to your drawing or painting; ideally, the model should be one to two metres from you. If you are working from a photograph, make sure it is stuck down and squared up to your working surface. The example below shows how to correctly position the nose with this technique.

1 Close one eye. Holding the pencil out in front of you, align the pencil at an angle to your selected area; for instance, the outer corner of the eye to the corner of the mouth, tear duct to nostril or top of the ear to the eye.

2 Keeping the pencil at the same angle, swing your arm across to hover over the paper without changing the angle and mark that line lightly on the drawing.

3 Repeat the process to check that the line you have drawn is correct.

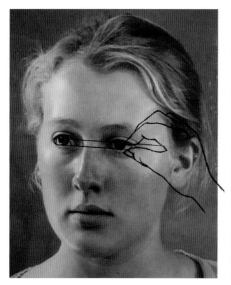 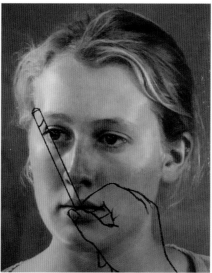 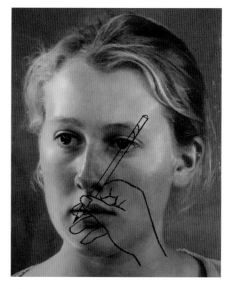

Assessing the angle of the eyeline: the tip of the pencil aligns with the outer corner of the model's right eye, and the pencil is tilted until it crosses the outer corner of the model's left eye.

The angle between the model's right eye and base of her nose.

The angle between the model's left eye and base of her nose.

 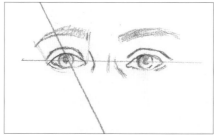 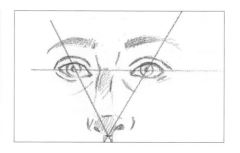

Proportional measuring

This is a method of comparing a unit of length on the model, or in a photograph, with an area on your drawing. The measurements can be the same size as your reference, enlarged, or reduced. To begin, the simplest approach is to use 'same size' measuring.

To do this, hold out the pencil at arm's length, either vertically or horizontally (depending on what you are assessing). It is important that the distance at which you hold the pencil is consistent, or the measurement will be distorted.

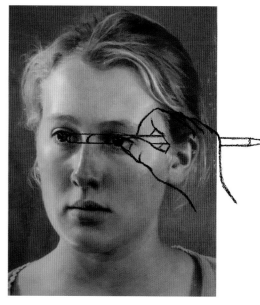

1 Close one eye. Align the end of the pencil with what you want to measure, then slide your thumbnail along the pencil to determine the unit of measurement.

2 Compare this unit of length with another area of the same distance. For instance, to find out how far the ear is from the nose, measure that distance and, keeping your thumb in the same place, find an equal width or depth on your drawing – perhaps the distance from pupil to pupil, or pupil to mouth.

3 Transfer this information to your drawing; use the pencil to measure the same distance on your drawing (e.g. pupil to mouth on your drawing will equal nose to ear) and mark that on the paper.

4 Continue to measure, cross-referencing throughout the drawing process, to ensure that the proportions and spaces are accurate.

In this example, the end of the pencil is aligned with the model's right pupil and the thumbnail with the left pupil, giving us a unit of measurement.

LOUISE *Coloured pencils*

This portrait was made using the techniques described here.

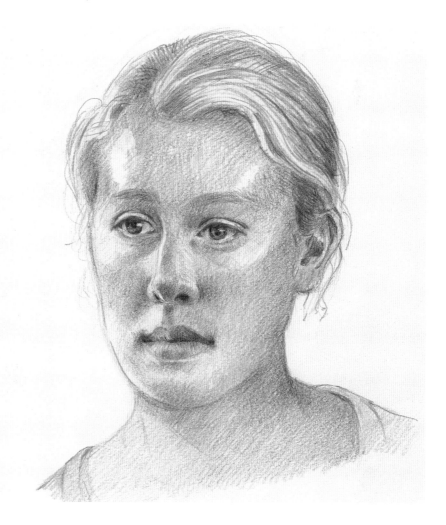

GEOMETRIC SHAPES

Looking for the angular shapes throughout a portrait or a figure is another way of analysing what can be a fairly complicated subject, as shown here.

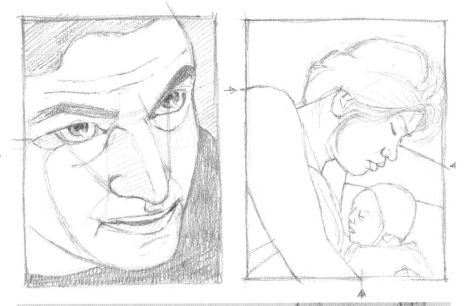

Above right:

LOOKING UP *Graphite pencil*

This unusual viewpoint, with the features foreshortened and distorted, makes a fascinating – if somewhat challenging – portrait study. Seeing it as a series of angular shapes and abstract patterns rather than trying to draw what you think of as eyes, nose, mouth etc, will help you to analyse it better.

Above far right:

MOTHER AND BABY, SLEEPING *Graphite pencil*

As well as finding this a charming subject, I loved the interplay of angular forms – the mother's arms framing and enfolding the tiny baby. As a starting point, I marked where the mother's arms dissected the edge of the photograph and blocked in the large main shapes. I drew the mother's head, and by comparison, the much smaller baby's head.

Right:

DAVID READING *Soft pastel*

Drawing the whole figure can sometimes be more dynamic than just a head-and-shoulders pose. I liked the pattern of primary colours and the zigzag of angles set against the converging lines of the settee and the rectangular shapes of the window in the background.

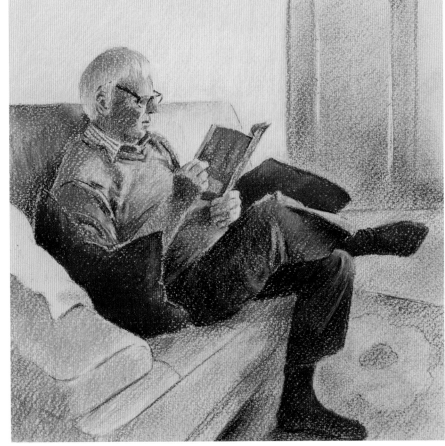

ABSTRACTING YOUR SOURCE MATERIAL

Learning to draw is really about learning to see, training our brains to analyse what is in front of us and interpret that truthfully rather than reproduce how we think something should look. Viewing a familiar subject in a new way encourages us to analyse what we actually see rather than follow a preconceived idea. It helps us, therefore, to draw what we see and not what we think we see.

Upside-down drawing

The aim of this exercise, inspired by the artist Dr. Betty Edwards, is to allow the right-hand side of the brain to take over from the usually dominant left-hand side. The right-hand side is the intuitive non-verbal side which thinks in patterns or pictures. It is this side which should be dominant for an accurate drawing, allowing you to faithfully evaluate angles, dimensions, shapes and patterns. The function of the left-hand side is to reduce thoughts to numbers, letters and words; it is the verbal, rational side and consequently looks at the visual world in terms of symbols – this is an eye, this is a nose etc, and can dictate the way you draw them.

Mark a rectangle the same size as the photograph on your paper, then turn the photograph upside down. Excluding all other distractions, concentrate solely on drawing the shapes you see. Do not think of it as being an upside-down version of someone you know but as a series of interesting curves, lines, and contours.

Starting at the top, work across and down, copying as accurately as possible. Do not attempt to turn the picture the right way up until you have finished.

In engaging the right side of the brain you should be unaware of the passage of time and be able to blot out sound and other distractions to feel alert but relaxed, almost trance-like. Allow fifteen to twenty minutes' drawing time, then turn the paper the right way up. You will have produced an accurate drawing of the photograph – and may have surprised yourself!

BOB WITH PIPE
Graphite pencil

ISRAELI GIRL *Graphite pencil*

LIGHTING

When setting up a composition it is important to consider the direction, quality and intensity of lighting on the model. Artificial light is controllable and constant. It should come from one direction and be gentle, or diffused, rather than too harsh.

Good lighting serves to enhance the form of the features; it should not cast heavy shadows that distort the form. If you choose to use natural light, it will change throughout the day and with weather conditions. A northern light is the most consistent.

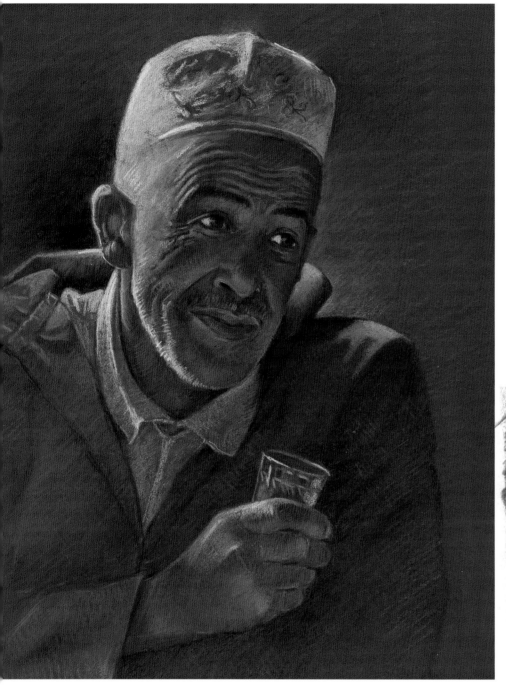

CONTRE-JOUR - THE OLD POTTER *Pastel pencil on Coloursoft textured paper*

Contre-jour is a traditional lighting approach, which means 'against the light'. It is effective for producing strikingly atmospheric results.

On a visit to Marrakesh, we were invited by this elder to take tea with him and his family. He sat against the window, the light spilling across his head and shoulders, and catching the top of his hand and the glass.

SEMI-SILHOUETTE
Charcoal and white pastel pencil

In this contre-jour profile study I love the exciting semi-silhouette effect, the features and glasses being finely outlined by the strong light source behind. Although the majority of the head is very dark by comparison, there are subtle suggestions of the form along the jawline and in the hair detail.

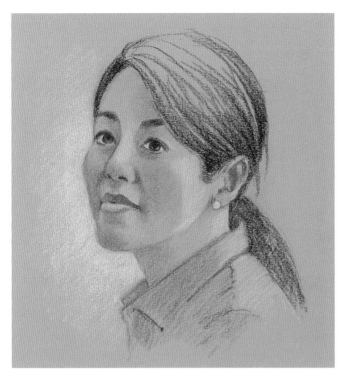

NATURAL LIGHTING - ELLEN
Pastel pencil on buff tinted pastel paper

A soft, diffused light catches the right-hand side of Ellen's head, creating a sensitive effect. In keeping with this gentle approach, the shadows are soft and the treatment of her black hair understated.

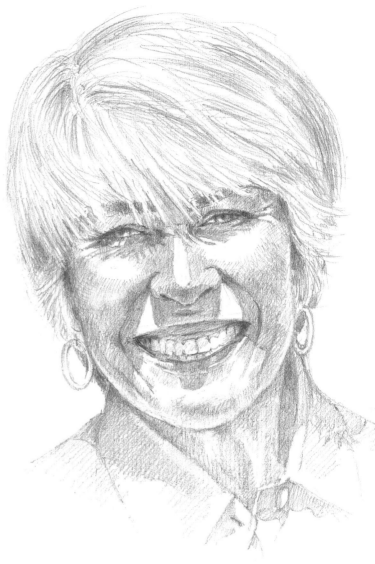

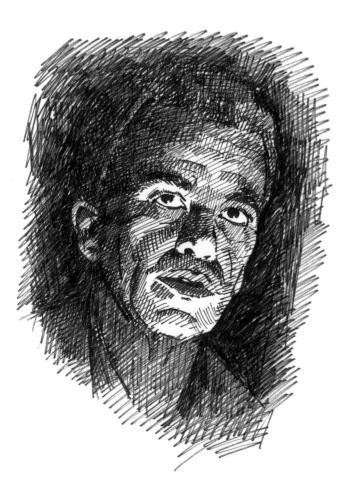

STRONG SUNLIGHT - ANN IN BRITTANY *Graphite pencil*

Sometimes you take a photograph that demands to be turned into a portrait study. Though not ideal for many portraits, here the bright sunshine casts shadows across Ann's face, increasing the feeling of hot weather and happy holidays.

UPLIGHTING - NIGHT PORTRAIT
Felt tip pen

Reversing a conventional source of light can create fascinating effects. Here the light source is from below, creating a very dramatic effect, throwing shadows up across the face, warping the features. The emphasis is very much on the eyes. The outline of the head fades into blackness.

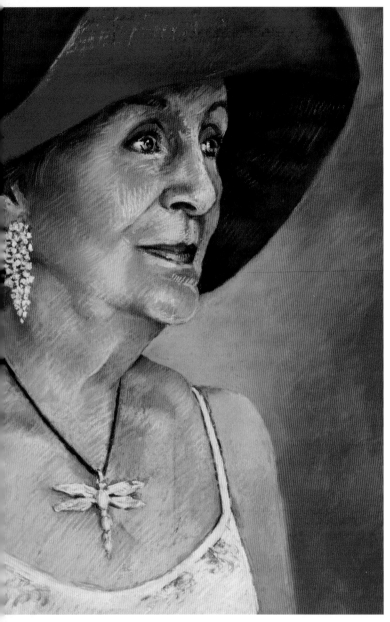

JILLY IN RED HAT *Soft pastel on Fisher 400 textured board*

I wanted to reflect Jilly's exuberant character, so used reds and oranges both in her clothing and skin tones. Warm reds were used on the side of her face nearest us, whereas I used bluish pinks and purples for the far side. I also used cool greys, and lilac to help offset the dominating reds.

COLOUR

The names of the colours on drawing media vary greatly between manufacturers, and from medium to medium. When using soft pastels, once the outer wrapper has been removed, the identification is lost completely. It is difficult, therefore, to give a definitive guide to colour mixing for portraits, but there are basic principles that may help when you are confronted with a colourful array of pencils or paints, whatever the medium.

Colour temperature

There are three primary colours – yellow, blue and red. These are colours that cannot be mixed from any other colours. Each of the primary colours has a warm and cool version.

Yellow Lemon yellow is a cool colour; cadmium yellow, raw sienna and ochre are warm colours.

Red Scarlet, vermillion and cadmium red are warm reds whereas crimson or permanent rose are cooler reds as they have a hint of blue in them.

Blue Ultramarine would be classed as warm blue, but cerulean, spectrum or Prussian are cool blues. Cobalt sits between cool and warm, and so is sometimes called a neutral blue.

When you first start using colours, the differences may not have much significance but as you become more experienced, you will be able to use the warm and cool versions more effectively. For example, using a warm red in the skin or on the cheek nearer the viewer will help make that side come forward. Conversely, using a cool crimson on the other side will cause it to recede. Similarly, ultramarine may be used on the near side of blue clothing, with a cooler blue used on the far side.

Observe and check

- Shadows may look black or dark brown in a photograph; replicating this can make a portrait look dull or muddy. Instead choose blues, purples, dark greens or a mixture for a more animated and interesting result.

- Where the skin is thin over the skull, the area of the lips, the creases of the ears and the nose appear redder. Increasing this slightly helps to add more life to the portrait.

- Skin tones often mirror the surrounding colours. Using a touch of colour from the background or clothing in the portrait can help produce a harmonious whole.

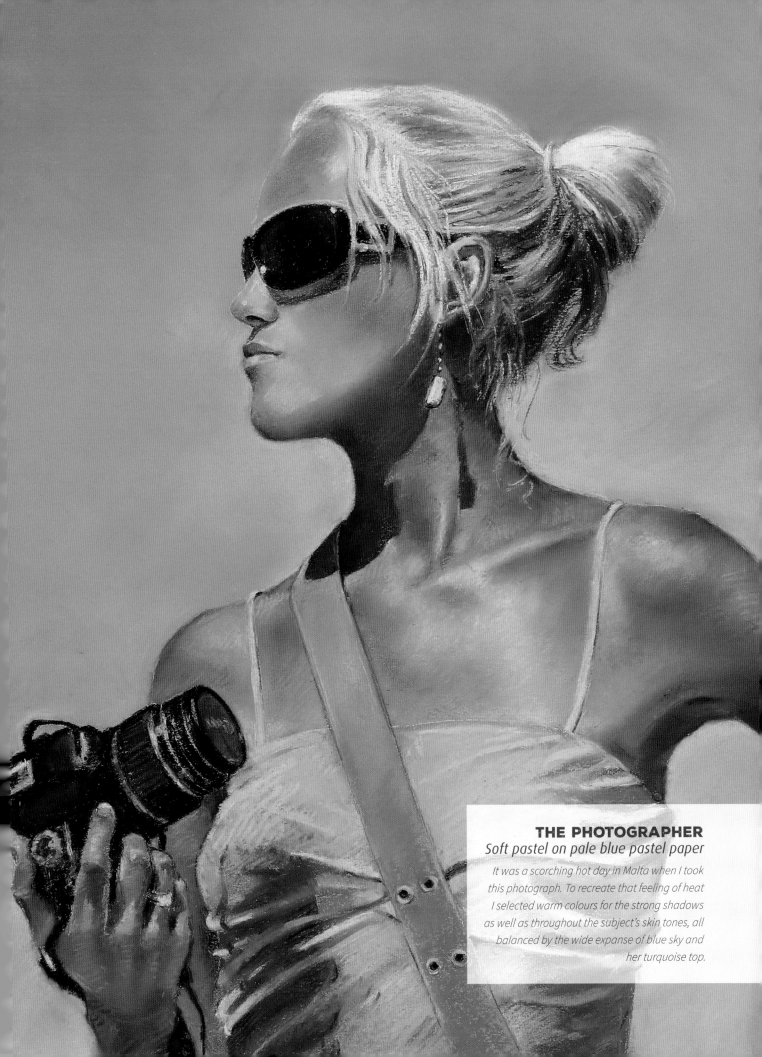

THE PHOTOGRAPHER
Soft pastel on pale blue pastel paper

It was a scorching hot day in Malta when I took this photograph. To recreate that feeling of heat I selected warm colours for the strong shadows as well as throughout the subject's skin tones, all balanced by the wide expanse of blue sky and her turquoise top.

STORY

A deeper understanding of your subject will be gained by considering those extra attributes that he or she possesses. Adding personal touches makes for a more interesting portrait. The pose, the clothes, the accessories – a special piece of jewellery, a favourite evening gown, work or sports garments – will all add an extra dimension.

As well as furniture and props, symbolism, mirror images, active and passive movement (such as a distinctive hand gesture), or some historical reference can convey an underlying story line which will embellish the portrait and grab attention.

One commission I did was of a prominent figure at the Bank of England. Struggling to find the right pose, his wife mentioned that he is never without pencil and paper – that essential 'something' that will help to make the finished portrait typically 'him'.

BACKGROUND

A background can contribute a great deal to your portrait. It can describe the sitter's social status, wealth, career, achievements or hobbies; it can include family members and pets. The setting may be a garden, a work place or a library; whatever you choose will add an insight into the subject's situation and increase interest in the portrait.

CONTRAST IN TONE *Soft pastel*

This simple background follows the maxim 'light against dark, dark against light'. The right-hand side of the head is a dark tone, so the background is light, whereas the profile is midtone, so the background is darker. Using these contrasting tones gives a depth to the study and makes the head stand out.

RELEVANCE AND MOOD *Soft pastel*

Placing the figure against a floral background brings a pretty, soft feminine feel to this portrait.

THE READING ROOM *Graphite pencil*

John sits comfortably in his armchair, surrounded by a background of books, which lends a scholarly feel to the portrait. A well-chosen background can contribute a lot to a portrait, and shed a light on an aspect of the sitter that might not otherwise be visible.

CONNIE KNITTING
Charcoal pencil

Connie was a regular attendee at one of my annual portrait courses, travelling from Holland by train, boat, train and taxi well into her nineties. I sketched her busy knitting for one of her young relations, as she was never one to waste time.

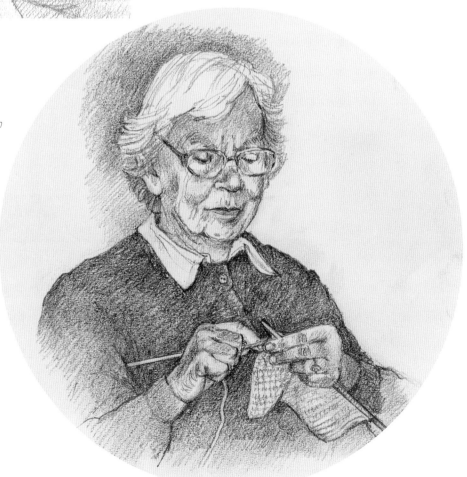

THE BRETON FISHERMAN
Watersoluble pencil

I spotted this interesting fellow at a village fair in Brittany in fancy dress. With his battered hat, apron, rods and leather fishing case, there's no mistaking his pastime!

Opposite:
RAJ IN PPE GEAR
Soft pastel

Whilst writing this book, I, like much of the rest of the world, have been in 'lockdown' as a result of Covid-19. I was given the opportunity to say 'Thank you to the NHS' by painting Raj, who had bravely volunteered from a cardiothoracic ward to join an ITU unit caring for Covid-19 Patients. This portrait, unusual in that most of the subject's face is covered, revealing only her eyes, has become symbolic of an unprecedented time in history.

CLOTHING AND PROPS

Neckline

How the contours of a shirt, blouse or t-shirt enclose the neck is an important, often overlooked, part of the portrait. The line of clothing should wrap itself around the human form thus adding a rounded, three-dimensional feeling.

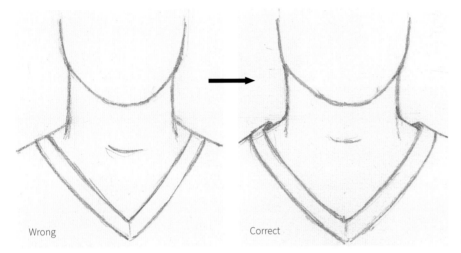

Wrong Correct

The neckline of a collared shirt reveals the line of the shoulders as well as the neck. Continuing the line of the shirt beyond the neck will help you achieve a smooth curve.

Line of the shirt

The line of the t-shirt should not stop at the shoulder line – as shown in the image on the left – but should curve around the neck. Continue the curved line of the clothing around and behind the neck, as shown on the right. This creates a more three-dimensional feel to the drawing.

Jewellery

The line of a necklace can help to show the contours of the neck, and a pendant helps to define the centre line of the sitter's body. Jewellery needs careful drawing but it must not take prominence over the subject.

If you are working from a model, it helps to takes photographs of such details so you can work on the portrait without the sitter being present.

Hats

Hats add to the character and broaden the 'story'. They can be tricky and need to look as if they fit the head rather than floating above it.

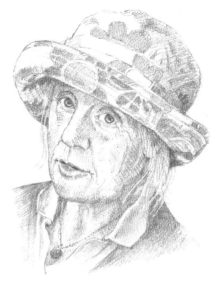

Red line: Continue the outline of the skull under the hat to ensure the width and depth are correct. Blue line: Draw the elliptical line where the hat sits on the forehead, then the larger ellipse of the brim; complete by adding the crown.

ELSIE *Graphite pencil*

This lady loves her hats and I think they add to and are part of her character, particularly this floral sunhat.

NIEL IN CAP *Graphite pencil*

Caps suggest more relaxed headgear, further endorsed by the beer glass. Draw the depth and angle of the cap carefully to make it look as if it is really sitting on his head.

Glasses

Glasses can help to accentuate the planes of the face. They are useful for drawing the angle of the eyes and establishing the position of the ear. Before you start or take photographs, ask whether your sitter prefers to wear them or not.

 Some lenses may catch the light and partly obliterate the eyes; but they can also add sparkle to this part of the face.

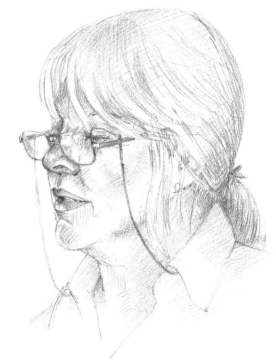

THICK FRAMES *Coloured pencil*

Heavier glasses can overpower the portrait and dominate the face, particularly if the frames are dark. If necessary, underplay their weight.

CHRISTA *Graphite pencil*

The glasses perched on the end of her nose give my hard-working pupil a studious air.

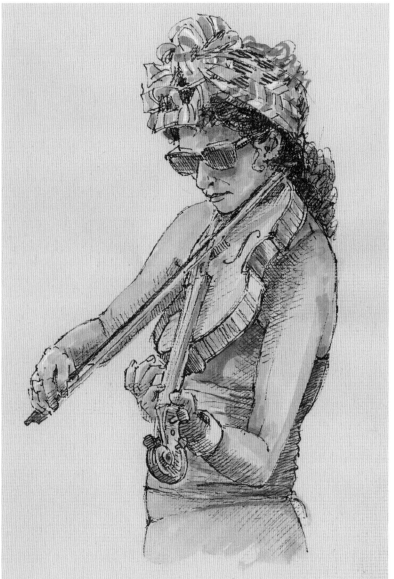

PETER IN COSTUME *Soft pastel*

The cap and kerchief characterize traditional 'peasant' costume, which Peter enjoyed wearing for this sitting.

GIRL WITH VIOLIN *Pen and watersoluble pencil*

This young musician was entertaining shoppers. I liked her stance and style as well as her music and did several sketches, and took photographs. The violin is the central axis in the portrait, and once drawn, one can construct her figure around it by looking at the negative spaces.

EDNA SHOPPING
Pastel pencil on Ingres pastel paper

Edna's colourful scarf encloses and frames her face, emphasizing her weatherworn features as she searches for bargains in the market.

ELLA *Pastel pencil*

Strong patterns can dominate a portrait. The floral
dress is very pretty but one needs to find a balance
between enhancing the portrait and overwhelming it.

MAN IN A HAT *Soft pastel*

The dark hat and overcoat in conjunction with the dramatic uplighting contribute to a
powerful portrait that uses only four colours.

TWO LITTLE BOYS *Pen and ink*

The vulnerability of these two young boys is
emphasized by their baggy, oversized clothing and
shoes. They look shy and apprehensive.

MAASAI WARRIOR

This portrait is based on a photograph of a Maasai warrior which I have enlarged using the grid method detailed on pages 100–101. There is more information on working from photographs on page 98.

I chose to use pastel pencils and soft pastel for this painting because I felt they would best reflect the rich colours of his skin tones, the vibrant red hues of his clothing and the haze and heat of his surroundings.

MATERIALS

- Masking tape
- Tracing paper same size as photograph
- Graphite pencil or pen
- Ruler and set square
- Pastel paper
- Drawing board
- Pastel pencils – Derwent: Venetian red, burnt ochre, burnt orange, crimson, maroon, burnt carmine, raw umber, chocolate, flesh, fresh green; Faber Castell Pitt Pastel: Vanilla
- Soft pastels: crimson, red, peach, purple, brown, orange, dark green, cream, white, pale green, lime green and blue
- Tortillon and kneadable eraser

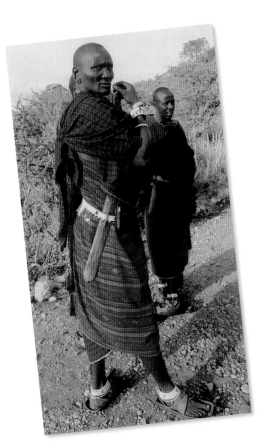

The source photograph for this drawing.

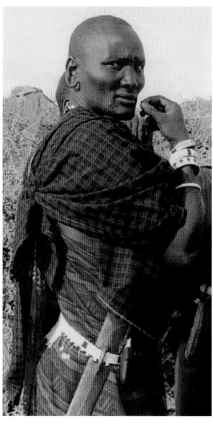

1 Select how much of the reference photograph will make a suitable portrait. I have cropped out the other figure and the background to concentrate on the head and upper torso of the warrior.

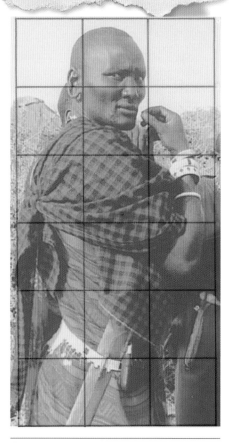

2 Tape the tracing paper to the photograph. Select the area of the photograph to be enlarged and use the ruler and set square to draw a grid with the pencil or pen, dividing the width and the depth into suitably sized squares (see pages 100–101 for more information).

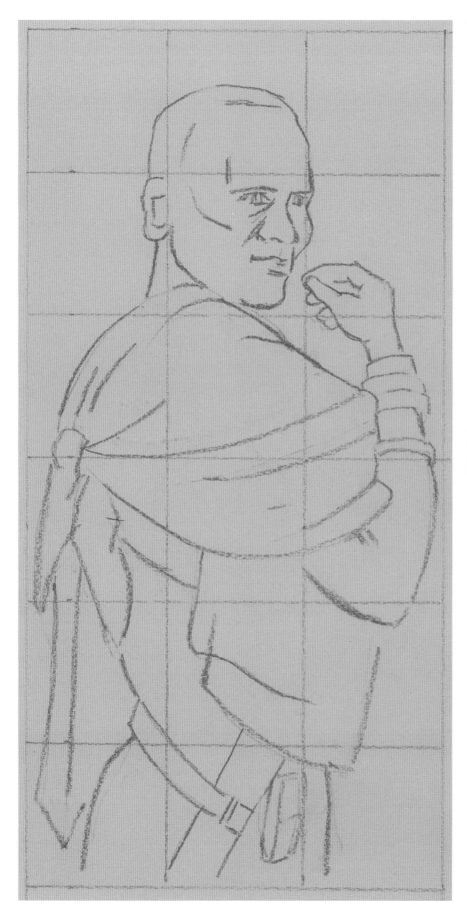

3 Secure your paper to the board with masking tape and elevate the top of the board to form a sloping work surface. Ensure the reference photograph or photocopy is alongside and squared up to the paper. Faintly draw an enlarged square grid on the pastel paper with the Venetian red pastel pencil. I have made mine 300 x 160mm (11¾ x 6¼in), twice the size of the small grid. Switching to the brown pastel pencil, note where the grid lines cross the image on the photograph grid and duplicate the outline of the warrior on the large grid on the pastel paper.

TIP

Remember that when using charcoal or pastel you need to work on a bigger scale than with pencil or ink, as it is a broader medium.

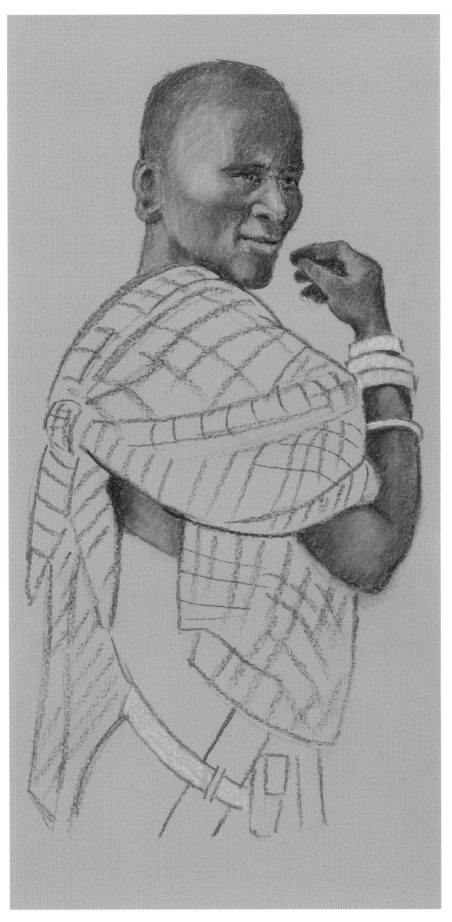

4 Erase the grid lines where possible, particularly in the background. Starting at the top, use the pastel pencil to create the colours and tones of the head, hand and arm, using a cotton bud or tortillon to blend where necessary. Sketch in the chequered pattern with a red pastel pencil. I worked on the skin tones starting with the mid colours with a combination of warm colours: burnt ochre, burnt orange, crimson, maroon, Venetian red, burnt carmine, raw umber and chocolate, adding lighter tones with flesh and vanilla. I added white to the bracelets and belt and the pattern on his cloak with a red pencil.

TIP

To prevent accidentally smudging your work, cover it with a piece of paper taped down lightly at the edges.

THE FINISHED DRAWING
Pastel pencil and soft pastel

For the final stage, I switched to my soft pastels to add richer, brighter colours to complement my subject's deep skin tones. I strengthened the colours in his face with crimson, red and peach, adding purple and brown for the darks – his hairline, the far side of his head and the shadow on his arm and hand. Hot and cool reds and orange were used for the cloak with dark green, purple and brown used for the pattern. For the highlights I used a cream pastel, and white for the bracelets and belt; the white soft pastel being much stronger than the white pastel pencil.

Lastly, I put in the background to increase the contrast with his skin tones. The first step was to use a pale green pastel pencil to outline the figure, before adding broader stokes with a soft pastel on its side to block in pale and lime greens and a touch of blue, which I then smudged in with my finger.

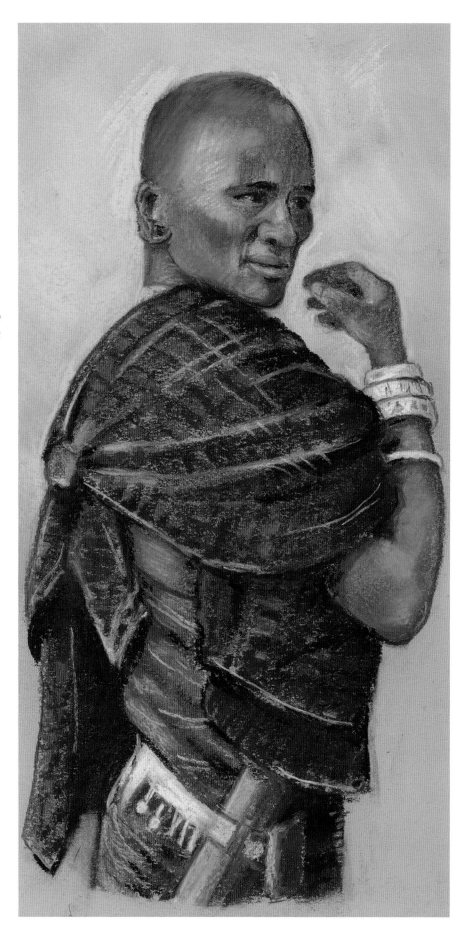

CORA

This is a freehand drawing using a pencil and a fibre-tipped pen. Cora came to one of my painting holidays in Italy; her vitality and youthful outlook belied her years. I was able to sketch her as well as taking photographs from which I have worked back home in the studio.

I did several preparatory sketches from my photographs to explore the features, using the hatching lines to follow the contours of her face. This also helped me to decide which view to use, while practising my shading techniques for this portrait.

MATERIALS

- 2B pencil
- Cartridge paper
- 0.5 mm fibre-tipped pen
- Coloured pencils (optional)

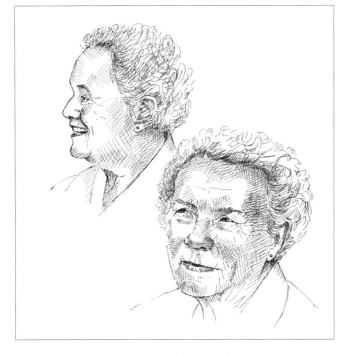

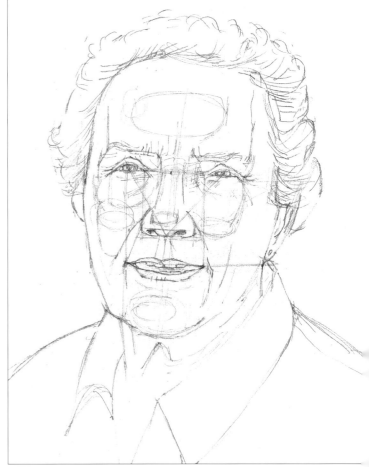

Here are my initial sketches. The profile view above shows quite a heavy brow and small eyes with a well-shaped nose, while the three-quarter view was from a higher viewpoint and did not show her eyes very well. I decided to use a third view (shown to the right), which I thought best expressed her character – looking animated and happy.

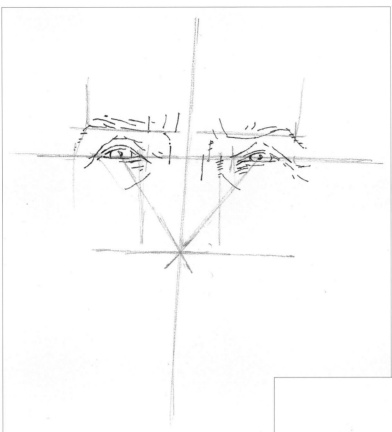

1 Using the pencil, draw the angle of the eyeline and the central axis on the cartridge paper, then use the triangular measuring system to plot the length of the nose. Switching to the pen, start by putting in dots to plot the position of the eyes and eyebrows, then draw them in using as economical a line as possible. Use a broken or dotted line for a lighter feel, for instance for the eyebrows and creases at the corners of her eyes.

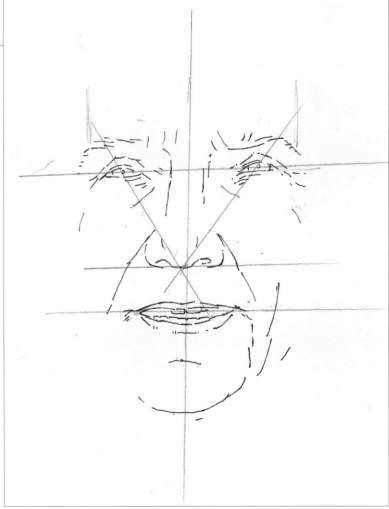

2 Construct vertical lines in pencil from the nostrils to the eyes to establish the width of the nose; as it is a slightly three-quarter view, the bridge and the end of the nose are not central. The three horizontal pencil lines ensure that the eyeline, base of the nostrils and mouth are in alignment. Compare the distance from the base of the nose to the middle of the mouth or the base of the upper teeth. Study the shape of the lips carefully, and if necessary make the mouth a little more smiley by slightly turning up the corners. Draw in the laughter lines at the edges of the mouth, delineate the cheeks, then sketch in the chin.

3 Draw in the shape of the head, starting with the temple, then the cheeks, the left-hand jawline, then the other side. Check the height of the forehead by comparing its depth with another distance, such as the width between the pupils. Draw the hairline, then the outline of hair. Coming down the right-hand side, put in the ear, neck and clothing. At this stage look at the change of plane from the front to the side of the head at the temple, round the eye socket and cheekbone and down the cheek itself.

THE FINISHED DRAWING
Graphite pencil and fibre-tipped pen

The last stage of adding shading to complete the portrait using pen is perhaps the most daunting part, so needs to be done sparingly. Add directional hatching following the planes of the head, the aim being to enhance the form, creating highlights without overdoing darker areas. Develop the lines of the eyelids where they are deeply recessed, and darken the eyes, leaving small highlights. The outline of the head on the left can be a broken line to create interest.

Look for alternating highlights and shadows in the hair and use varied, directional marks to create movement. To bring the hair and forehead into one shaded form, continue hatching on the right-hand side across both the hair and the temple. Moving on to the mouth, darken the corners and the inside of the mouth; add hatching and cross hatching marks to the neck and around the collar, darkening at the point where the neck and shirt meet.

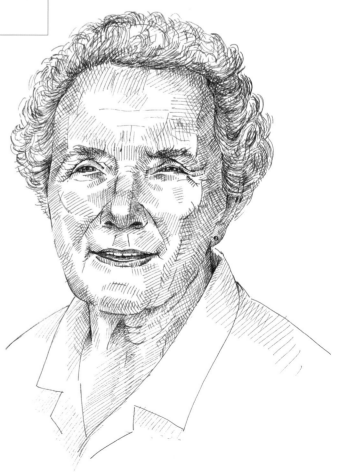

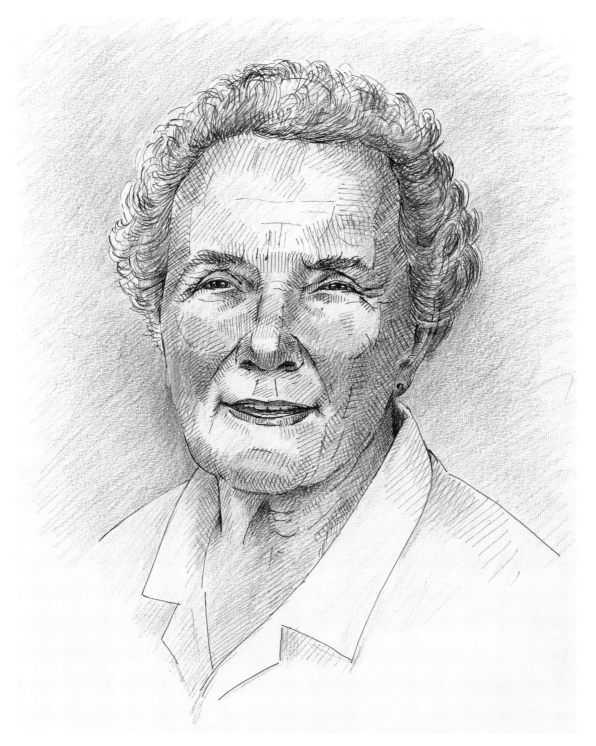

DEVELOPING THE FINISHED DRAWING
Graphite pencil, fibre-tipped pen and coloured pencil

I added some colour to the head and also in the background to bring it to life. This is an optional stage, and requires a light touch – you don't want to overwork your portrait. Walk away when you think you are nearly finished and see whether you really need to add anything more.

EXPERIMENTING

The examples in this book suggest some basic rules to follow so you can begin drawing and painting portraits. I hope these examples and step-by step guides have been helpful and encourage you to attempt portraits yourself.

There are probably as many ways to approach this intriguing subject as there are faces to draw, so why not be adventurous, experiment with different drawing and painting mediums and other surfaces and create your own style. The examples in the final section of this book show a few different approaches you might like to try.

Doing short studies from life (such as *Steve*, below) is a good challenge that will improve your observational skills as well as your drawing technique. The more you do, the easier it becomes and the quicker your drawings will be.

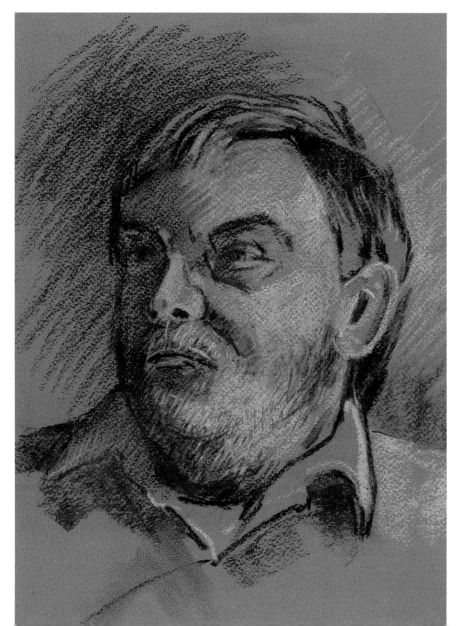

STEVE *Pastel pencil and pastel on blue paper*

Drawn in twenty minutes. This dramatic lighting effect is called 'chiaroscuro' from the Italian meaning 'light and dark'. One side of the head is in deep shadow as opposed to the brightly lit left-hand side which I have highlighted with a peach skin tone pastel.

THE FAB FOUR *3B graphite pencil*

It is an interesting exercise to analyse familiar faces, identifying the different head shapes and features to distinguish what really makes each individual portrait recognisable. I found Paul's likeness the hardest to capture. What do you think?

DIANA
Watersoluble pen on cartridge paper

I found it challenging to get a good likeness of Diana; she has an elusive quality that is hard to pinpoint – maybe that is what made her so captivating! Using a pen can be daunting, but by adding water to this watersoluble variety, you can brush away mistakes. Once dry, they are permanent, and more pen can be added. They can also be mixed with watersoluble pencils.

MARY AND ROO *Soft pastel on blue-grey Canson pastel paper*

I had wanted to paint a portrait of my neighbour for some time, and Roo decided to get in on the act too. I took lots of photos and worked from three or four to find the right pose for both Mary and her faithful companion. Using soft pastels I was able to experiment, changing the position of her legs, her left arm and the height of the settee, which I lowered so that it would not dwarf her.

EDWARD *Pentel brush pen*

I plotted the main points of the head and features in graphite pencil before using the brush pen to draw the portrait. This is obviously a bold medium to use and would not be suitable where a more delicate feel was required. Depending on the pressure applied the brush pen line can vary from thin, fine lines to much heavier ones. Be brave – have a go with this interesting technique!

ERIC *Charcoal*

A fifteen-minute study. I used a charcoal stick on its side to completely cover my white cartridge which I then smudged in with a tissue to produce an overall mid-tone grey ground; I did the drawing with the charcoal stick and used a shaped kneadable eraser to effectively lift out the lighter tones which appear white. I redefined the features where necessary with the charcoal stick and darkened other areas.

RON RESTING *Coloured pencil on textured cartridge paper*

A full figure portrait, like this one of Ron relaxing in his garden chair, is sometimes more telling of character than the more usual head-and-shoulders pose. The same rules for proportional measuring and measuring the angles (see pages 116–117) can be used for drawing the figure accurately.

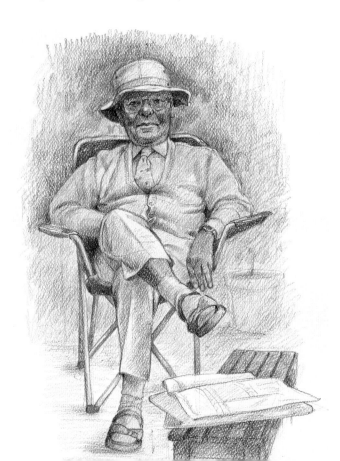

Like any skill, portraiture demands lots of practice, so keep drawing, keep practising and happy portrait painting!

INDEX